PRACTICAL GILDING

PETER & ANN MACTAGGART

Archetype
Publications

First published 1984 by Mac & Me Ltd.
Reprinted 2002, 2005 and 2009 by Archetype Publications Ltd

Archetype Publications Ltd.
6 Fitzroy Square
London W1T 5HJ

www.archetype.co.uk

Tel: 44(207) 380 0800
Fax: 44(207) 380 0500

ISBN 1-873132-83-2

Printed and bound in Great Britain by Antony Rowe, Chippenham

Preface

Gilding is not a difficult process but it is one which has been surrounded by secrecy. The techniques which are used to handle gold leaf owe nothing to other craft practices, and because of the cost of the leaf and also because gilding is a trade in which work is finished for other craftsmen it has not attracted amateurs.

If one needs a gilder today, he is unlikely to be in the next street, and any advantage in efficiency which the professional gilder can offer has to be offset against the cost of transporting the work to him. If a modern craftsman wishes to have his work gilded he is likely to have to gild it himself.

This book is an attempt to set down detailed descriptions and explanations of the traditional, professional methods of both oil and water gilding in a way that can be followed by another craftsman. It does not discuss some of the methods that have been suggested recently for amateur use. These have been designed to reduce the skill required at one part of the process, but they often make other parts more difficult. Like any skill, gilding requires practice, but if the well-tried methods are followed, and the would-be gilder is prepared to use more leaf and spend more time than the professional, he or she should be able to produce a perfectly satisfactory result.

Like the techniques, the recipes for the varnishes and gesso are those which are used in our own studio, but it should be noted that the metric and imperial quantities that are given are not the exact equivalent of each other. One should either work with one set of units or the other.

The authors are grateful for the help they have received from a number of fellow craftsmen, and are particularly indebted to James Robinson and to W. Habberley Meadows for reading the manuscript and making valuable suggestions.

<div align="right">A.M.
P.M.</div>

October 1984

Contents

Part 1. Gold and Other Leaf 1

Goldbeating 1, Types of gold leaf 2, Silver and other metal leaves 4, Metal powders 5.

Part 2. Tools Used in Gilding 6

The gilders' tip 6, The gilders' cushion 7, The gilders' knife 8, The mahlstick 8, Brushes 9, Other tools 10.

Part 3. Gold Size and Resists 11

Gold size 11, Preparing surfaces for leafing and bronzing 14.

Part 4. Oil Gilding 17

Working positions 17, Applying gold size 17, Painting lines, and other brush techniques 18, Testing oil size for tack 19, Gilding with transferred leaf 20, Using transferred leaf in whole sheets 21, Handling loose leaf 22, Cutting the gold 27, Laying the gold 27, Pressing the gold down 29, Faulting 30, Cleaning up 31, Removing gold size 32, Gilding mouldings and carving 32.

Part 5. Gesso 35

Glue size 35, The size coat 36, The *intelaggio* 36, The gesso 37, Recutting and water polishing 38.

Part 6. Water Gilding 41

Clays 41, Making and applying bole 42, Applying the gold 44, Double gilding 45, Faulting 46, Burnishing 46, Bright and mat gilding 47, Water gilding combined with paint 48.

Part 7. Special Techniques 49

Transferring designs 49, Lettering 50, Gold powder and shell gold 53, Strewings or spangles 54, Metal powders 55, Schlag leaf 56, Metal and colours 57.

Part 8. Varnish 61

Varnish on gold 61, Making up varnishes 63, Ormolu and other shellac varnishes 63, Mastic and dammar varnishes 64, Ketone resin N varnish 65, Changing white metal leaf to a gold or other colour 65.

Part 9. Gold bands on Harpsichords 67

Suppliers 69

Further reading 70

Index 71

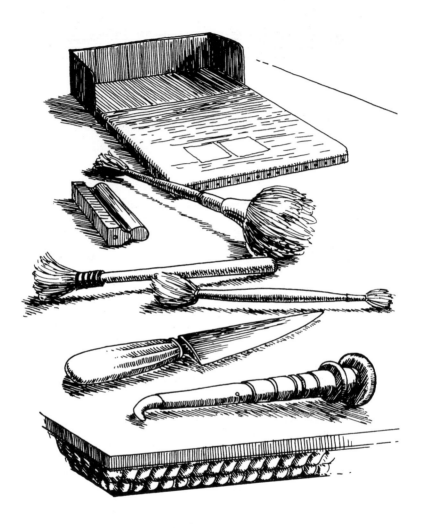

Late seventeenth-century gilders' tools. Redrawn from Felibien's
Principes de l'Architecture

Part 1. Gold and Other Leaf

Goldbeating

Although there have probably been more radical innovations in the way gold leaf is prepared during this century than in the previous four hundred years, much of the process has hardly changed. This can be seen from a detailed account given by William Lewis in his *Commercium Philosophico-Technicum* of 1763–5. The gold was cast and, already in Lewis's time, was passed between polished steel rollers

> till it becomes a ribbon, as thin as paper ... The ribbon ... is cut with sheers into equal pieces ... these are forged on an anvil till they are an inch square, and afterwards well [an]nealed ...

A pack was made from 150 of these gold squares, interleaved with pieces of vellum, and with about twenty more vellum leaves on the outsides. This was, and still is, known as a 'cutch'. The vellum leaves were 3–4″ (75–100 mm) square and the gold was beaten until it was the same size as the vellum. The pieces of gold were taken out, cut into four with a steel knife and then interlaid in the same way with ox-gut skins 5″ (125 mm) square to make a cutch of 600 leaves. The beating was repeated 'till the golden plates have again acquired the extent of the skins, [when] they are a second time divided in four' with a cane knife. For the last beating, the gold was divided into three parcels which were beaten separately until they were large enough to be cut into leaves. Lewis explains that the leaves

> are taken up by the end of a cane instrument, and being blown flat on a leather cushion, are cut to size, one by one, with a square frame of cane made of a proper sharpness, or with a frame of wood edged with cane; they are then fitted into books of twenty five leaves each, the paper of which is well smoothed, and rubbed with red bole to prevent their sticking to it.

Lewis gives some interesting details of the interleaving membranes which play such a vital part in the making of the leaf.

> The gold beaters use three kinds of membranes; for the outside cover, common parchment, made of sheepskin; for interlaying with the

gold, first the smoothest and closest vellum, made of calves skin; and afterwards the much finer skins of ox-gut, stript off from the large streight gut slit open, curiously prepared on purpose for this use, and hence called gold-beaters skin. The preparation of these last is a distinct business, practised by only two or three persons in the kingdom ... It is said, that some calcined gypsum, or plaster of paris, is rubbed with a hares-foot both on the vellum and the ox-gut skins. ... The beating of the gold is performed on a smooth block of marble weighing, from two hundred to six hundred pounds ... Three hammers are employed, ... the first, called the cutch hammer, is about four inches in diameter, and weighs fifteen or sixteen pounds, ... the second, called the shodering hammer, weighs about twelve pounds, and is about the same diameter: the third, called the gold hammer, or finishing hammer, weighs ten or eleven pounds, and is near of the same width.

Today a larger gold ingot is cast than in the eighteenth century. It is rolled into a continuous ribbon 130′ (40 m) long and 2″ (50 mm) wide which is cut into 2″ squares. These are placed between skins and beaten four times instead of three. Until the early part of this century all gold leaf was beaten by hand, and some of it still is, but in the 1920s a machine was invented which could reproduce the action of a hand-wielded hammer. A more recent development than the mechanized hammer is the beating of gold between sheets of plastic instead of goldbeaters' skin. Apart from this, the changes are few: the skins are still rubbed with calcined gypsum – 'brime' powder – applied on a hare's foot; the leaves are still cut on a leather cushion to the same size – 3¼″ (83 mm) square – using a cane-bladed 'waggon' and then placed between rouged paper using boxwood tweezers. The books still contain 25 leaves. From the figures Lewis gives, the quantity of gold which was used to make a cutch can be calculated, and it would appear that the weight of a leaf of gold has changed very little in the past two hundred years.

Types of Gold Leaf

The purity of gold is expressed in 'carat'. This is the number of parts of pure gold contained in a metal which is thought of as being composed of twenty-four parts. Thus pure, or 'fine', gold contains twenty-four parts of gold out of twenty four, and can be described as 24 ct. An alloy which contains twenty-two parts of gold and two parts of other metals is known as 22 ct, while one which contains eighteen parts of gold and six parts of other metals is called 18 ct and so on. The other metals are added to gold to increase its hardness and change its colour, for example reddish shades are produced by adding copper, while white gold is made by adding silver. These coloured golds assay between 12 and 22 ct depending on the proportion of other metals that they contain, and are known by such

names as white, pale lemon, middle green etc. Fine gold is used in manuscript illumination and occasionally in high-quality exterior gilding. It is the most malleable leaf it is possible to obtain. 'Regular' gold is 22 ct, and this and 23¼ ct gold are the grades most used by professional gilders.

The fancy coloured golds are usually only available in the thickness known as 'single weight', but fine and regular gold can also be obtained in thicker leaves. A manufacturer's 'selected gold' is likely to be slightly thicker than his single weight or 'standard', but 'double gold' is not necessarily twice the thickness of single. Fine gold may also be obtained in 'triple weight'.

Apart from differences in weight and colour, gold leaf is supplied in two forms, called 'loose' and 'transferred'. In a book of loose gold each leaf is merely placed between the rouged sheets, and if you handle the book awkwardly, the leaves can slide out or become creased. In the case of transferred leaf, a rectangle of tissue, rather larger than the leaf, is slipped into each opening of the book, and the book is then pressed hard enough for the gold to become attached to the tissue. Today transferred gold is the only type of leaf used by many amateur gilders. In the past it was used exclusively for work out of doors where any breeze could have carried loose gold away. Some nineteenth-century books describe how to make a form of transferred leaf by rubbing tissue paper with candle wax and placing cut pieces of this tissue between the pages of the book to secure the gold. When a gilder did use loose gold out of doors, he usually rigged up a draught screen around the place where he happened to be working, and this may have contributed to the idea that he wished to protect the mystique of his craft from the eyes of passers-by.

Transferred gold is only suitable for oil gilding, and may not be available from gilders' sundriesmen and artists' suppliers in such a wide range of weights and colours as loose gold. Most gold beaters, however, will transfer any leaf they beat. The pressing it receives during transfer seems to impart a slight texture to the leaf so that it cannot be made to equal loose gold in the brilliance of its surface. Although loose leaf requires a larger initial outlay on equipment, it can be used in places where it is difficult to apply transferred leaf, and much of the technique of using it holds good for both oil and water gilding. If you do not expect to oil gild on more than one occasion, transferred leaf will produce a satisfactory result with minimal outlay. If on the other hand you wish to gild regularly, it could be well worth while acquiring the skills of cutting and handling loose leaf.

The cost of a book of gold can vary considerably; it depends on the manufacturer, the country of origin, the type of retailer and the weight of the leaf. Some art shops stock gold leaf, but the best

selection is available from gilders' sundriesmen and from the goldbeaters themselves. It does not always pay to buy the cheapest gold. An experienced gilder may be able to get a good result using single weight leaf because of his skill and delicacy of touch, but if you are learning to use loose gold, double weight will stand more inept handling.

Silver and Other Metal Leaves

Silver is beaten out into slightly larger leaves than gold — about 3¾" (95 mm) square. Like gold it is sold in books of 25 leaves. It cannot be beaten as thin as gold and once laid it must be varnished to prevent it from tarnishing. During the seventeenth, and the early part of the eighteenth century, silver leaf covered with a yellow varnish was often used as a substitute for gold on furniture and picture frames and also in interior decoration. Silver leaf, protected with a clear varnish, was also used in its own right on the silvered furniture which was briefly in fashion during the latter part of the seventeenth century. On surviving examples, however, the varnish has discoloured so that it is now difficult to decide which pieces were intended to look like silver, and which like gold. Silver leaf must be kept wrapped during storage to exclude as much air as possible, but it will probably still be necessary to cut off the edges of the leaves when one lays it to prevent the joins from showing as dark bands.

From medieval times until perhaps as recently as the eighteenth century, a bright, non-tarnishing, white-metal leaf was made from tin. Today, white gold, platinum, palladium and aluminium are used instead. Platinum leaf is very expensive and like palladium is made slightly smaller in size than gold leaf. Aluminium is cheap and is supplied in sheets which are about 6" (150 mm) square and greyish in colour. White gold can be beaten thinner than the others and provides the most brilliant surface.

Schlag leaf (literally hammered or beaten leaf), also known as Dutch metal, is a thick leaf made of an alloy of copper and zinc. It is available in copper–red and yellow shades. Schlag leaf tarnishes, and it is advisable to varnish it unless it is only wanted for a temporary effect. The sheets are approximately 6" (150 mm) square. As it is cheap it is used for theatrical properties and sets, and for other schemes where gold would be too costly. It is sold in books of 25 leaves and in packs of 500 – usually without interleaving tissue – and like silver leaf it must be well wrapped for storage.

Gold can be beaten thinner than any other metal. Platinum, palladium and silver leaf, though thicker, can be handled in the same way as gold, but different techniques are used to lay aluminium and schlag and these are discussed in part 7.

Metal Powders

Gold can be bought, ground up and mixed with a little gum arabic, in small tablets which contain 1 dwt – pronounced penny-weight – of gold (1.56 gm). This is an expensive way of buying gold, and today its main use is in restoration.

Gold in powder form was once widely used on japanned work. Today it is available from only a few suppliers, but if you have difficulty in obtaining it, you can make your own by following the directions given in part 7.

Bronze powders are easy to obtain and they can be bought in a variety of forms and colours. Most of them will tarnish quickly if left without a protective coat of varnish, and although there are tarnish-resistant grades these are expensive compared with standard bronzes. The colours range from pale gold to copper, and there is also a brown shade called 'penny bronze'. The particle size of the powders varies: standard bronzes consist of relatively large flakes (although they are not visible to the naked eye), while lining bronzes are finer and burnishing bronzes finer still. Until recently, bronze powders were made by stamping, but they are now made in ball mills and have less lustre than the older bronzes.

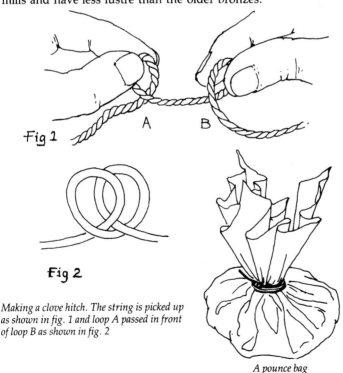

Fig 1

A B

Fig 2

Making a clove hitch. The string is picked up as shown in fig. 1 and loop A passed in front of loop B as shown in fig. 2

A pounce bag

Part 2. Tools Used in Gilding

The Gilders' Tip

As gold beaters managed to produce thinner leaf which was more easily damaged, specialized techniques were developed to handle it. In the fifteenth century some gold leaf must have been thicker than it is today, because Cennini described how it could be picked up with tweezers, placed on a piece of card and slid onto the work. By the eighteenth century, a ball of cotton wool enclosed in fine linen was being used to pick up cut pieces of leaf while whole leaves were lifted using a squirrel's tail. Another way of picking up gold, employed by some bookbinders when lettering on the curved spine of a book, was to use a piece of cane bent into a 'U' shape with a piece of silk stretched between the arms of the 'U'. In the nineteenth century a special brush called a 'tip' was developed, and this has become the standard tool for picking up gold. Tips are made by gluing a thin layer of hair into a handle made from two pieces of card. Squirrel and camel hair are used for gold, while badger is strong enough to pick up aluminium and schlag leaf. As bought, tips are slightly wider than a leaf of gold, and are available with three different lengths of hair. Short tips are used to handle small pieces of leaf, medium tips for half leaves and long tips for pieces which are larger than half a leaf. None of the tips are large enough to lift an entire leaf, and whole leaves are picked up most conveniently with a 'double tip' made by fastening two tips one behind the other. It is useful to have more than one tip of each size so that you have a

A group of gilders' tips. On the right are two tips, stapled together and with a cork glued on as a handle, for lifting whole leaves of gold

spare if one of them accidentally becomes contaminated with water or gold size. It can also be useful to have one which can be cut up, as a narrow piece cut from a tip makes it easier to manoeuvre gold into small awkward places. Store tips between pieces of card so that the hairs are kept flat and straight.

The Gilders' Cushion

Loose gold is cut with a knife on a padded, leather-covered board which is known as cushion in this country and as a 'klinker' in America. Cushions can be bought from a gilders' sundriesman, but if you cannot get one, you can make a cushion yourself. Cut a 6" x 10" (150 x 250 mm) rectangle from ⅜" (10 mm) plywood. Cover it with one or two layers of felt, baize or other fine, even-textured cloth to form a pad about ⅛" (3 mm) thick and the same size as the board. The padding must be firm and even or the gold will remain uncut in some places when the knife is drawn across it. A piece of fine calf or chamois leather, with its rough side up, should be stretched tightly over the pad and tacked or stapled to the underside of the board. A draught screen is fitted around one end of the cushion to stop the gold from being disturbed as you move about. The screen is about 6" (150 mm) high by 14" (350 mm) long and is traditionally made from a strip of parchment. Paper can be used, but it needs to be of a quality which will stand repeated folding without cracking because the screen is usually folded flat when the cushion is not in use. One holds the cushion rather like a painter's palette, by slipping one's thumb through a strap which is fixed to the underside of the board. The leather surface of the cushion is cleaned and kept free from grease by rubbing it occasionally with the rouged tissues from an old book of leaf.

Draught screens which remain folded for long periods tend to become set, and it can be difficult to get them to stay upright. If this

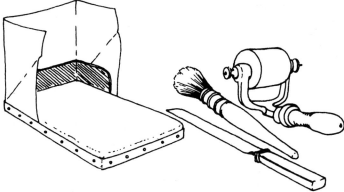

A gilders' cushion, showing an improvised support for the draught screen

happens, make a support from a strip of thin card about 1½" (40 mm) high by 11" (280 mm) long. Bend it so that it will sit inside the draught screen with its lower edge caught between the parchment and the cushion. Dust the support with whiting so that the gold will not stick to it.

The Gilders' Knife

A knife is essential for cutting loose gold on the cushion. You can buy a special gilders' knife or adapt a straight-bladed table knife. If you choose the latter course, the blade must be not less than 6" (150 mm) long, and free from kinks and notches. The edge must be sharp enough to cut the gold cleanly but not so sharp that it will cut the cushion. Sharpen the knife with a very fine water hone of the type used for razors and then polish the edge using rouge on leather. This will make it too sharp, and it should be carefully blunted by drawing it across a piece of softwood covered with rouge. The knife will need resharpening periodically; so if, after a while, you find that the gold is not separating cleanly, check the state of the knife blade. A nick, which is so small that a lens is needed to see it, will tear the gold. You may be able to feel a nick in the blade if you run your fingernail along the edge.

The Mahlstick

One might think that a mahlstick is an odd item to include in a list of gilders' tools, but it can be used to steady the brush hand and as a straight edge when painting lines. The stick is traditionally made from a stiff, round wooden rod about ⅜" (10 mm) in diameter and 2–3' long (60–90 cm) but versions are also available which unscrew into short lengths so that they can be packed into a signwriters' box. A firmly-padded ball, covered with leather or velvet and about 2" (50 mm) in diameter, is fastened to one end. When it is placed on the work, the ball supports the stick so that it can be held parallel with

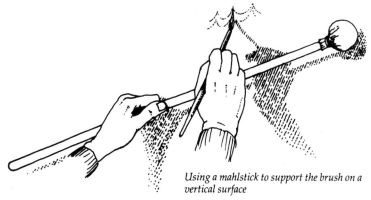

Using a mahlstick to support the brush on a vertical surface

the surface, and the leather or velvet should provide just enough friction to prevent the stick from slipping.

Brushes

Although gold size is undeniably hard on brushes, and they will not last long, you still need to be as fussy when choosing round brushes to paint patterns or lettering with as you would if they were to be used for watercolour painting. When you are buying brushes, ask for a pot of water if one is not available; wet each brush in turn; shake out the surplus water and then try painting a few strokes on the heel or back of your hand. Rotate the brush slightly between successive strokes and watch to see if the hairs divide at the tip. If they do, it is unlikely that the brush will make a reliable point when it is full of gold size. While you are testing the brush, note how much spring there is in the hairs – brushes which bend and stay bent should be rejected. Flat-ferrule brushes seldom need to be tested for the reliability of their edge, although you may decide to check the resilience of the hairs and this can only be done wet. Try to avoid buying brushes which are packaged up so that they cannot be examined.

Brushes called writers are sometimes set in quill instead of in a metal ferrule and the sizes are given as lark, crow, duck, swan etc. The handles for these brushes are sold separately. They will need to be fitted carefully, and the taper may have to be modified, so that the handle supports the quill almost as far down as the hairs. Soften the quill by soaking it in cold water for a few minutes before attempting to push it onto the handle. The hair of quill-mounted writers is softer and longer than that of round, artists' brushes and operates on a different principle. Instead of drawing out the sticky medium by virtue of its spring, the long hair clings to the surface over a relatively large area and the stroke is made slowly to allow time for the size to flow from the brush.

To clean up brushes, wash them first in white spirit, until no more colour comes out, and then in soap and water. Pay particular attention to the heel of the brush because if gold size collects in it and hardens, the hairs will eventually break off and become stuck in the work. While the hairs are still wet, shape them into a point and leave the brush to dry where it will not be touched.

A gilders' mop is a fat round brush with hairs of squirrel, badger or pony. It is used for patting the gold into contact with the size and brushing off the waste pieces of leaf, which are called skewings. Buy a good-sized mop, the large mass of hair which it contains will have greater resilience than a small one but the brush will still get into crevices satisfactorily. The ferrule can be as large as ¾″ (20 mm) in diameter and the brush may be numbered 8 or 10. If you fit a small quill-mounted mop onto the end of the handle of your large mop, it

will save you having to put down one brush to pick up another when patting gold down in awkward places.

Other Tools

You will need a pounce bag. This is a small bag filled with gilders' whiting which is used with a gentle patting motion to distribute a fine, even dusting of chalk so that the gold will only stick where you intend it to. It is needed in most oil gilding jobs, and is particularly useful when one is gilding patterns and lettering. The bag is easily made from a 6" (150 mm) square of old, fine cotton sheet. Put a dessertspoonful of gilders' whiting in the middle of the square. Make a clove hitch in a short length of strong thin cord or string; gather up the corners and edges of the square; slip the clove hitch over the little bag and pull the knot up tight. Wind the ends of the string round the neck in opposite directions and tie them off. Gilders' whiting is natural chalk which has been levigated to free it from grit. Some people suggest dusting with french chalk or talc (both are forms of steatite) or with precipitated chalk, but these are less satisfactory than natural chalk because they are extremely fine powders, which can become ingrained in the surface of paint, and it can be difficult to remove them when you have finished gilding.

If you intend to water gild you will need some burnishers. In the past dogs' and wolves' teeth were used for small burnishers while larger ones were made of haematite. Today burnishers are usually made from agate, and the description 'dogs tooth' refers to a shape rather than the material. The agate is set into a metal ferrule and mounted on a thick wooden handle so that you can grasp it firmly for long periods without tiring. If you need a large burnisher for big areas, it is an advantage to fit a handle that is long enough to reach your shoulder as then you will be able to apply greater pressure to the surface you are burnishing without straining your wrist. Burnishers, especially large ones, are expensive and should be kept in a cloth roll or have separate covers made for them. Keep them well away from garnet and emery paper because if they become scratched they will not produce a perfectly burnished surface.

Burnishers which have become slightly scratched, and new ones which are not perfect, can be repolished by first removing the damage with 400 or 600 grit 'wet and dry' paper, and then polishing them on felt impregnated with cerium oxide powder. This should be obtainable from a lapidary supplier but putty powder, which is tin oxide and which will polish more slowly, can be substituted if you cannot get cerium oxide. Wash your hands and the burnisher when changing from one grade of abrasive to another so that none of the coarser material is carried over to the next stage of the polishing. Use plenty of water as a lubricant with both papers and powder.

Part 3. Gold Size and Resists

Gold Size

Sometimes referred to in old books as 'mordant gilding', oil gilding is the easiest technique for the amateur to master. Unlike water gilding which will be damaged if it is merely wiped with a damp cloth, oil gilding can be used both in and out of doors. The only disadvantage of using oil size is that the gold cannot be burnished. Briefly, the technique of oil gilding consists of: applying a resist to the surface to prevent the gold from sticking in the wrong places; brushing gold size onto the area which is to be gilded and waiting for it to reach the right stage of tackiness; covering the size with gold and pressing the leaf onto the size, and finally removing the excess gold from the work. In this chapter and the next, these processes and some of the materials which are used are considered in detail.

The main constituent of gold size is linseed oil which has been heated with a drier, traditionally a lead oxide. Driers shorten the drying time by combining with the oil and increasing its affinity for oxygen. The speed at which the treated oil will dry depends on the drier, the quantity that is added and the length of time the oil is heated with it. Other constituents include copal varnish, which is added to promote through drying of the film, and to prevent the size from forming runs when it is applied to a vertical surface. Turpentine may be added if the oil/copal mixture is too viscous to allow it to be brushed out to a thin film. Some old recipes for size include venice turpentine; this is a thick turpentine resin, which will help to form a smooth glossy surface that is free from brush marks, but if too much is added the size will form runs.

Manufacturers designate their sizes by their drying time: for example 2–4 hour, 8 hour and 16 hour. This last is the slowest size which can be bought now that 24-hour size is no longer made. 'Quick Japan' gold size takes the least time to dry – usually one to two hours. It forms a rather brittle film and is used mainly when gilding out of doors where the short drying period reduces the amount of dust which can stick to the size.

In addition to the different drying times, gold size can be bought in two forms – clear or mixed with yellow pigment. Clear sizes made

in France are labelled *Mixtion Clarifiée*; English clear size may be described as 'writers' size. Yellow pigmented size, which does not seem to be offered by French manufacturers, is sometimes described as 'old oil size'. In the past it was pigmented with yellow ochre, but during the nineteenth century, chrome yellow (lead chromate), which has a much finer particle size, began to be used and this has become the standard pigment. The yellow colour makes it easy to see the area which has been painted and also enhances the appearance of the gold.

As yellow sizes are not easy to locate today, you may find it necessary to make your own. You can do this by adding artists' quality, oil paint to clear size (some gilders add yellow gloss paint instead), but either will lengthen the drying time of the size. Choose an opaque pigment such as yellow ochre, chrome yellow or nickel titanate, and if the tube of colour contains excess oil squeeze the paint out onto absorbent paper and leave it overnight so that the free oil is removed. To make about 8½ fl oz (250 ml) of yellow size you will need a glass or marble slab which is at least 16" (400 mm) square, a small measuring jug, a glass jar with a well-fitting metal lid and a good quality, kitchen palette knife. Start by measuring 7 fl oz (200 ml) of clear gold size into a small container. Squeeze the whole of a 40 ml tube of oil paint onto the slab; add a little gold size from the measured amount, and mix it well with the colour using a palette knife. More size can then be mixed in, a little at a time, until the paste becomes runny. Transfer the mixture to the glass jar and add the remainder of the gold size. Stir well. When you have finished, you should paint out a test area of the mix to find its drying time. This will probably be a little longer than that of the size you used.

Clear size is usually sold in tins which have a small screw cap. When the tin is partly empty a skin may form on the size. If a skin forms, as it always does on japan size, transfer the remainder of the size into a wide-mouthed jar so that any new skin which forms can be removed cleanly before the size is poured into a small dish for use.

Oil sizes have self-levelling properties and set to a smooth, glossy surface. The longer the gold size takes to become tacky enough to gild, the better its gloss will be. However, because of the long drying time more dust is likely to settle on the surface, so dust-free working conditions are desirable. Slow gold size not only develops the best surface for gilding, it also stays 'open', that is to say in a state where it can be gilded, for longer than a quicker size. In practice, this means that one can gild a greater area in one session with an 18-hour size than with an 8-hour size. When using a 4–5 hour size on moulded or carved work it is easy to cover a larger area with the size than can be gilded while the surface is in the right state of tack. However, if you stop for an hour between putting the size onto the

different parts of the work, you can ensure that the size is not all ready to gild at the same time.

One needs to plan ones work around the length of time the size takes to dry. For example if a 12-hour size were put on first thing in the morning, it would still not be gildable when one was thinking of stopping work for the day: if one put it on in mid-afternoon it could well be too dry to gild by first thing the next morning. Generally, sizes that have a short drying time and which can be applied and gilded within one working day, or slow ones which can safely be left overnight, are the most convenient to use. Lines that are less than about 2 mm can present a problem, especially if you are painting them in 2–4 or 4–5 hour size, as they are likely to be ready to gild in two thirds or three-quarters of the time that the size would normally take. The weather can also bring about noticeable variations in drying time; both dampness and cold tend to retard drying, while warmth and low humidities accelerate it. In Northern Europe, the actual drying times of quick sizes usually fall within the range given on the tin, but slow sizes may take much longer to dry. For example it was not unusual in England for a size described as 24 hour to take three days to come to tack, and to remain gildable for a further three days. In the Middle East the same size might be ready to gild within hours. If you are using a size with which you are not familiar, it is advisable to paint some out to see how long it takes to come to the right degree of tack, and how long it stays open.

You can mix two sizes together to make one with an intermediate drying time. For example, if you wanted some size which would take about fourteen hours to dry, you could mix some 16 hour and some 4–5 hour size. If possible, use two sizes made by the same manufacturer. You will need relatively little of the quicker size to reduce the drying time of the slow one. You can also lengthen the drying time of a size by adding some boiled oil to it. Never add raw linseed oil to gold size as it can 'sweat' through the gold and spoil it. When you make a modification to a size; you need to check that you have not altered other properties of the size as well as its drying time. Apart from its ability to 'hold up' on a vertical surface, the size should dry throughout its thickness. If too much oil is added the size may dry superficially but still be soft underneath and if this happens the gilding will remain vulnerable to damage, perhaps for weeks. Paint out a test of the mix to find out how long it takes to become gildable and then write the time on the can. Leave the gilded test patch for a week or so and then check it for hardness by scratching it with a fingernail before using it on a job. In the past sizes were often left to mature and this is confirmed by old books on gilding, which refer to sizes being kept for a year or more before they are used. Today, sizes are not formulated in the same way as the old ones, and there is no advantage in leaving them to stand.

Preparing Surfaces for Leafing and Bronzing

The surface to be gilded, whether gessoed or painted, should be perfectly dry, smooth and free from dust and bits. Gesso may be given one coat of thin shellac varnish to reduce its absorbency and to prevent the gold size from drying patchily.

When a painted area is to be entirely gilt the surface must be as perfect as possible because any defect will be more obvious once the surface is gilded. The grain of the wood must be filled, and any brush marks left from painting must be removed. Before the size is applied, the surface should be given a final light rub down with fine garnet or sandpaper to remove any little pips and then wiped absolutely clean.

Plain painted surfaces that are to be partly covered with a pattern in gold leaf should be left as they come from the brush as they cannot be smoothed or de-nibbed unless they are varnished or polished afterwards to conceal the scratches left by the abrasive. Brush marks and pips are less of a problem than they may sound as small flaws will not be noticed once the pattern has been applied.

If you are gilding on top of paint, you will need to apply a resist to the surface so that the surplus gold leaf is easy to remove. Even if the paint itself is not sticky, leaf will adhere readily to a slightly greasy area – even a fingerprint – and then it can be almost impossible to get the gold off without marking the surface.

In some commercial work, the edges of long lines and bands are defined using a self-adhesive tape; not masking tape, because gold size can seep under its slightly crinkled edges; but a thin red lithographic, or signwriters', tape which is flexible, has a low tack, and can be left on the work for several days without becoming difficult to remove. The tape is peeled off after the gilding is complete, taking the little overlaps of gold with it and leaving a clean, if hard, edge.

Probably the most widely used resist is gilders' whiting. Before you put on the size, pat lightly all over the area with your pounce bag, working to and fro in rows and overlapping the strokes to obtain a thin and even dusting of chalk. The pounce should cover the part which will be sized, and extend about ¾" (20 mm) outside it. Some people recommend that the chalk should be wiped off mouldings and other areas which will be gilded but this is only necessary when the chalk is applied too heavily. Apart from acting as a resist, the dusting of gilders' whiting has other uses. Designs, which are painted in clear size and which would be difficult to see against a plain coloured background, show more clearly if the surface has been pounced. A design can also be drawn or transferred directly onto the chalked surface (see part 7). Finally, chalk seems to have the effect of restraining the tendency of some thin slow sizes to spread on very smooth surfaces.

A solution of egg white can be used as a resist; it is painted onto the surface before the gold size is applied and wiped off after the gilding is finished. To make the solution, the egg white is strained to remove the thick parts and then diluted with ¾–1 pint (300–500 ml) of water depending on the size of the egg. Use cold water, as hot will 'set' the egg white, and in hard water areas it is better to use de-ionized or distilled water instead of water from the tap. The liquid is brushed over the area to be gilded and allowed to dry. Then the design is painted out in size and gilded as usual. On the following day the area is wiped with a slightly damp sponge to remove the egg white and any surplus leaf. The resist should not be left on the surface for more than a day or two, as albumen films become insoluble with continued exposure to ultra-violet light.

Some gilders like to use white of egg when gilding fine lettering. It is also useful when one metal is laid over another to produce a two-colour effect because if gilders' whiting is used on top of leaf it can scratch and dull the metallic surface. However it is advisable not to use an egg-white resist with silver leaf as there is a risk that the silver will be tarnished by the sulphur in the egg. Resists need to be used with bronze powders as well as with leaf. Standard bronzes are too coarse to become embedded in a surface whichever resist is used, but white of egg is better than gilders' whiting beneath aluminium powder and the fine lining and burnishing bronzes because it prevents them from becoming ingrained in the paint.

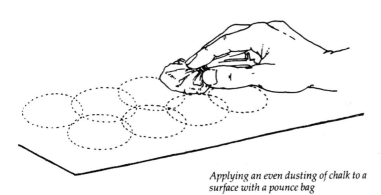

Applying an even dusting of chalk to a surface with a pounce bag

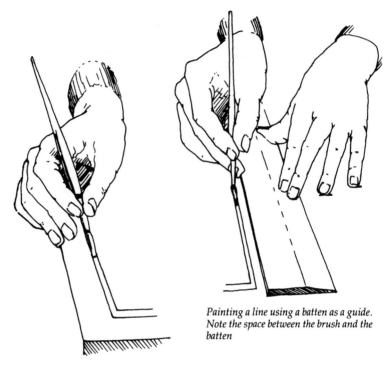

Painting a line using a batten as a guide. Note the space between the brush and the batten

The second and third fingers are run along the edge of the surface. The second finger also acts as a spacer by remaining in contact with the index finger

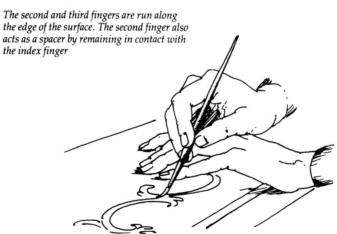

Supporting the brush hand over the work with the other hand

Part 4. Oil Gilding

Working Positions

After you have prepared the surface, the next process is to apply the size. It may take only a few minutes to cover something like a few feet of narrow moulding. However, if you are painting an intricate pattern, you may need to apply size for several hours at a time, and whether you are gilding as part of your work, or doing it as a hobby, you will find that it is less tiring if you arrange a comfortable working position. You should be able, with a little ingenuity, to raise a panel or small object to a suitable height and tilt it to a convenient angle. A panel tilted at 10 or 15° to the horizontal is much less tiring to work on than one which is laid flat. If the object is large and awkward and you can sit to work at it, choose a seat that is the right height, and if necessary use more than one height of chair. If you wear bifocal glasses, beware of positions in which you have to tilt your head back to look through the near vision area as the muscles of your neck and shoulders can become cramped if you have to do this for a long time. One cannot sit when combined arm and body movements are required – when striking long lines or large curves for example – but it is often practical to sit if the job consists of a lot of detail concentrated in one area. The most tiring working positions are those which involve bending over, or holding ones arms above shoulder height. If you are working on a fixture such as a cornice or a fireplace, try to stand on something which puts you at the right height in relation to the work. If this is not possible, frequent breaks are essential to enable you to move about and relax, because if your muscles are aching you will not be able to work with precision.

Applying Gold Size

Sable or ox-hair brushes are normally used for putting on gold size today, though some old manuals recommend hog bristle. However, the type of brush you use depends on how thick the size is, because the hairs must have enough spring to draw the size out evenly. Flat brushes are the first choice for large mouldings and also for wide bands where the edges have been defined with masking tape, while round brushes are better for putting size onto carving and narrow

mouldings. Round brushes are also valuable when painting patterns, particularly those involving scrolls and curves, because it is possible to make sharp changes in direction without lifting the brush from the work. When a band is to be painted freehand, it can be an advantage to use a writer for the edges and a wide brush to fill in the space between them.

Gold size has a rather treacly quality, and the art is to brush it out thinly and evenly as you apply it. This is because even a size that takes as long as eighteen hours to come to tack will begin to set shortly after it has been put on, and if you touch it once this has happened you will pick up the surface and make inequalities which are likely to show in the finished gilding. A further problem which arises if the size is thin in some places and thick in others, is that the thin parts will be ready to gild while the thick ones are still too soft.

At the end of a session, discard any size left in the dish as by then it will contain dust and bits. If possible, place the work so that the sized areas are vertical to reduce the amount of dust which will settle on them during drying, alternatively cover them with a paper tent.

Painting Lines, and Other Brush Techniques

One problem with long lines is how to make them perfectly straight. The use of adhesive tape to define the edges of lines has already been mentioned, but it gives a mechanical-looking result and you may prefer to try painting lines with your hand supported against an edge. You can often use the edge of the work itself as a register and slide your fingers along it, but where the line is too far in from the edge, a batten can be held on the surface of the work, parallel with the line, and used instead. If the batten is made thin enough, it can be used, not only on flat surfaces, but also on bowed and concave work. If you find your fingers sticking to the batten in hot weather, dust them and the batten lightly with talc so that your hand runs along the edge without juddering. Do not run the brush along the batten, because you may get gold size onto it and from there onto the work. To prevent the batten from slipping, it can be supported on small knobs of Blu-Tack* which can also be arranged so that they lift the batten clear of wet gold size. When curved lines on flat surfaces are being painted, a draughtsman's flexible curve forms a useful guide; it can be buttressed with Blu-Tack on the side away from the line.

When you are painting lettering or designs you may need some support for your brush hand. The most instant method is to use the other hand. Even more versatile is a mahlstick. This can be used on surfaces which are at any angle, and the padded end of the stick can

*Blu-Tack is a trade mark registered in the United Kingdom and other countries by Bostik Ltd.

be rested well clear of the area being worked on so that there is little risk of smudging the design. Some gilders find that a board, wide enough to take their hand comfortably and with blocks fixed on the underside at each end, forms a convenient support when working horizontally or on a slight slope. The blocks should run the width of the board, and be about ¾" (18 mm) square in section. The board is usually 10–18" (250–450 mm) long but the longer it is, the stiffer it must be. The blocks at the ends should be padded underneath with felt or foam rubber.

By resting ones hand on a support, not only is the risk of smudging the work avoided, but one has greater control over the brush. This is particularly valuable when painting letters, where great precision is required. By lifting the hand a little way above the work, a support enables a round brush to be held with its handle at right angles to the surface, so that the hairs can be swept in any direction to produce spirals, dots, leaf shapes, *treillage* or any other small motif. A support also enables one to work for longer periods without tiring.

Testing Oil Size for Tack

In their anxiety not to miss the period when the gold size is open, beginners often put the gold on while the size is still too soft, and as a result their gilding has relatively little lustre. Gold leaf which has been laid on soft size remains vulnerable to fingermarks and other damage for some time because the leaf excludes the air from the size and slows the rate at which it hardens. If one begins to gild when the size is too soft and it comes to the proper degree of tack while one is still gilding, the surface will be uneven in brilliance. However, a skilled gilder may use this change in the quality of the size to produce subtle differences in the brightness of the surface. Areas which are to be left mat are gilded when the size is still *slightly* soft. These can then be used to set off other parts, which are made as bright as possible by leaving the size until it is virtually dry before the leaf is applied.

There is a natural inclination to touch the size with a fingertip to find out if it is ready, but if you do this you will leave a mark which will still show when the gilding is finished. A traditional way of checking the state of the size is to bring the hairs on the back of your hand into contact with the tacky surface. If you feel a slight pull, the size is nearly ready to gild, but a decided plucking sensation indicates that it is still too wet. Some people draw a bent knuckle across the surface and if their taut skin rubbing on the size produces a slight squeak, they know that they can start gilding. This is a good confirmatory test and one which is often used by experienced gilders, but if the size is still soft, it can be marked badly. With practice it is possible to see when the size is approaching the right

degree of tack. The surface of fresh size has a wet glossiness which, when it is ready, becomes just a little duller.

Gilding with Transferred Leaf

In addition to a book of transferred leaf, you will need a pounce bag, a gilders' mop and a pair of scissors with blades which are about 3½" (90 mm) long, so that you can cut right across the leaf in a single movement. If you are using much transferred leaf, you may also need a straight edge, and a razor blade or knife as well as something to cut on.

When the size is ready, dust the blades of your scissors with chalk by patting them with the pounce bag. If you will be using only a few leaves of gold, take the transferred leaves out of the book one at a time, and cut them into pieces of whatever size you need. Leave some tissue border on each piece so that you have something to pick it up by. If you will be using many leaves, cut them out of the book in bundles of half a dozen, keeping the transferred gold between the rouged sheets. Then hold the bundle carefully but firmly by its edges, so that it cannot twist, and cut it into convenient-sized pieces. Six sheets are about as many as can be cut with scissors at one time. If you know that you will use all the gold in the book in one session, it is simpler to cut the spine off the book with a straight edge and a knife than to cut bundles out of the book. However, once the sheets are loose, the leaf becomes vulnerable to damage, particularly if it has to be saved from one day to the next. When you are cutting up the leaves, make the pieces not less than ¼" (6 mm) larger each way than the area which they will cover to allow for overlaps and any little breaks in the edges of the leaf.

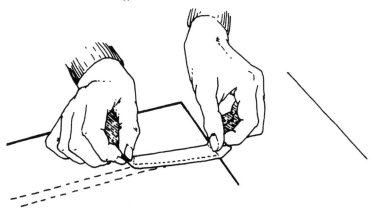

Applying transferred leaf. The knuckles of the fingers that are not holding the gold are resting against the surface to steady the hands

To apply the gold, take up a piece of leaf by its tissue border, and laying the gold against the sized surface, pass your fingers over the back of the tissue. Always stroke away from the end you are holding. You must hold the transfer leaf absolutely still against the surface once the gold has begun to make contact. Any sideways movement of the tissue will cause the gold to break. Be careful not to press the tissue backing into contact with the size because if this happens it will stick and spoil the surface. Once you have laid the first piece of gold, the end of the transfer sheet of the next piece can be gently held in place on the gilded area while the new piece is rubbed down. Lap each succeeding piece of gold over the previous one by about ⅛″ (3 mm).

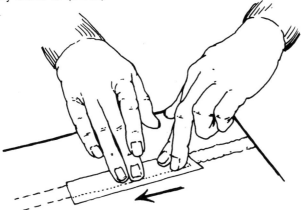

Once the gold is in place, stroke along the backing away from the end where it is being held

Using Transferred Leaf in Whole Sheets

As one might expect, whole leaves are used when gilding all-over patterns and large solid areas. Less obviously, narrow lines and small plain mouldings can be gilded without cutting the leaves. To gild a strip in this way, position the transfer tissue so that you cover the size with one edge of the sheet of gold. Rub the gold down lightly; then lift the tissue up and away from the work by the edge which still has most of the leaf attached to it. The gold should break cleanly at the size line. If you lift by the edge where the gold has been used you will tear the gold. Repeat the process, working across the sheet, until all the gold has been used. You can position the gold accurately on the size because the tissue is translucent enough for you to be able to see where gold is still adhering to the sheet.

Occasionally you may find books of transferred leaf which have not been pressed sufficiently hard. These are a real nuisance; at

worst the gold will drop off the tissue when it is inverted and before you have positioned it on the work, and it is only slightly better if the whole leaf detaches itself when you expected to use only a small part. If you cannot return such books to your supplier, reserve them for jobs where you are laying whole leaves at a time.

When you have covered all the size, any small breaks in the gold will need to be repaired – 'faulted' as it is called. How to do this and clean up the gilding is discussed in the sections on faulting and cleaning up at the end of this chapter.

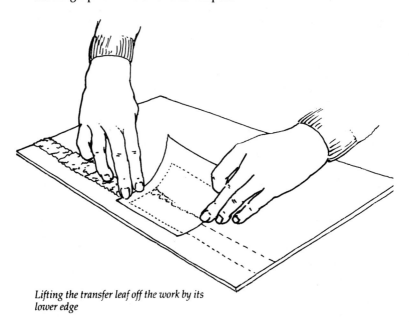

Lifting the transfer leaf off the work by its lower edge

Handling Loose Leaf

Loose gold can be cut and transferred to the work in a number of ways. Most of these have been developed by craftsmen to suit their special working conditions. For example signwriters, who often gild while balancing on a box and have nowhere to put anything down, seldom carry a cushion. They use their fingernail to cut the gold while it is still in the book and move it straight to the work with a tip. However, in the traditional method used by gilders who work in a studio or workshop, the gold is transferred from the book to the cushion where it is flattened and cut to size; the cut pieces are then picked up with a tip, laid on the work and pressed down. These

techniques are, like tying ones shoelace, easier to do than to describe. As well as a book of loose gold, you will need a cushion, knife, mop, at least one tip and some cotton wool wrapped in fine cotton. Before starting, rub your cushion and knife with some pieces of rouged tissue, or if these are not available, pounce the cushion and the blade of the knife with chalk.

There are at least three ways of getting leaf onto the cushion. The first is the easiest for the beginner. Set the cushion down so that you have two hands for the book of gold. Open the book at the first leaf and holding it flat, neatly and swiftly invert it onto the leather so that the leaf is near the front of the cushion and at a slight angle to the edge. Peel the book off the gold, and you should have a leaf deposited on the cushion, flat and ready for cutting. However, if you succumb to the temptation to put the gold out in this way all the time, you will never learn to handle gold with confidence, nor will you learn to work with the cushion in one hand and the tip or knife in the other.

As with many craft practices, the traditional, and apparently more difficult, way is quicker once you have gained sufficient experience. Take the book of gold and, beginning at the spine, roll it gently into a cylinder about 1" (25 mm) in diameter. Let the book unroll slowly, turn it over and roll it up again so that the other side is outermost. This will free the leaves from the rouged sheets. Open the book at the first leaf, and holding the edges of the other pages together so that all the gold does not fall out, tip the leaf into the back of the cushion. Help the leaf on its way with a gentle shake if necessary. The gold will probably land in a heap, but don't worry. Depending on what he was gilding, a professional might tip anything between a single leaf and a whole book.

One takes the creases out of the gold by picking it up on the knife blade, turning it over, laying it down on the cushion again and gently blowing on it. All the movements must be smooth and controlled. Put the book in a safe place and take up the knife. Using the flat of the blade, pat the cushion just in front of the heap of gold to create a slight draught and make the edge of the gold lift a little. Then, pressing the tip of the blade against the cushion, slide the knife under the edge of the gold and out on the far side. Lift the knife with the leaf draped over it until the gold is just clear of the cushion. Give the knife a gentle shake to help the creases to drop out of the leaf. If the gold slides off, try again. Roll the knife handle so that the far edge of the gold is lowered until it contacts the leather close to the front of the cushion. Continue to roll the knife away from you, moving it steadily towards the back of the cushion so that the gold is unwound off the blade. The gold should now lie at the front of the cushion with the side that was down, facing up. You can, if you prefer, roll the knife towards you and lay the gold out

Picking the gold up on the knife

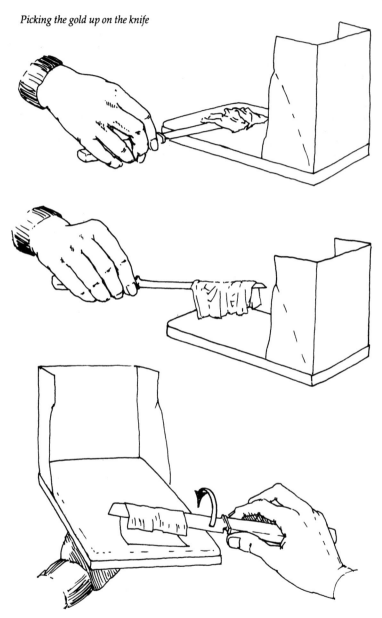

Turning the gold over. The knife blade is being rotated in the direction of the arrow

working from the back of the cushion to the front. It doesn't matter which way you work provided the gold is turned over.

After only one turn, unless you are very skilled, there will probably still be folds in the gold. You can remove small creases by blowing into the centre of the leaf as described below, but to remove larger ones you will have to repeat the process of patting on the cushion, picking up the gold and turning it over with the knife. The ability to remove the creases with the least number of turns comes with practice; as a general guide, the knife should be inserted parallel with the main creases in the leaf.

Blowing into the centre of the leaf to flatten it

You will discover by experience which folds can be improved by blowing on the gold between turns. Blow straight down making a narrow gentle stream of air, and aiming for the exact centre of the leaf. If you are blowing correctly, you will see a series of concentric ripples spread out towards the edges. Always blow after turning the gold for the last time and before you cut the leaf. This presses the gold into contact with the leather as well as removing any remaining small creases. If the leaf is blown off the cushion accidentally let it fall where it will; then pick it up on the knife and return it to the cushion. You will certainly damage the leaf if you try to catch it.

When you can handle a single leaf, try tipping several leaves into the back of the cushion. Pat just in front of the heap of gold to make it rear up a little, and try to pick up a single leaf. The process of collecting a leaf from the pile is similar to taking up a single leaf, except that you need to make a slight lifting movement as you slide the knife into the heap of gold. This will avoid the danger of poking a hole in a leaf or creasing it against the cushion. The whole process sounds slow, but it is surprising how quickly an experienced gilder can bring order to the most impossible-looking heap. Picking up a leaf, turning it over, blowing and cutting, eventually turns itself into a rhythm, and when you have had some practice, you will find that it is quicker to collect a leaf from a pile in the back of the cushion than to invert the book onto the cushion for every leaf. Another advantage of working in this way is that you can gild where there is no surface on which to lay a book of gold. By tipping several leaves into the back of the cushion at a time you can work without having to stop frequently to go and collect more gold from the book.

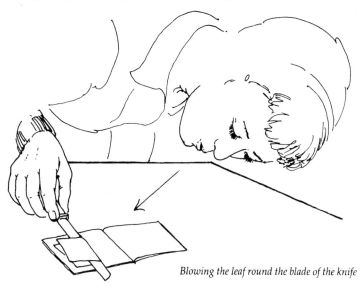

Blowing the leaf round the blade of the knife

In studio conditions, where one can arrange to have a place where a book can be laid, the following method of picking up the gold is very quick and convenient. Hold your gilders' cushion and tip in one hand as usual. Open the book of gold at a fresh leaf with the other hand and run your finger down the central crease so that the book stays open. Lightly place your knife flat on the gold so that the back of the blade lies across the centre of the leaf; then blow gently

across the spine of the book and towards the back of the blade at a fairly low angle so that the free half of the leaf is flipped over the blade of the knife. The gold can now be moved to the cushion and unrolled from the blade in the usual way ready to be cut.

Cutting the Gold

When a leaf of gold is cut, it is always divided into squares or rectangles which may be halves, thirds, quarters, eighths, sixteenths etc. of the leaf. Cut the gold into whatever sized pieces you require, but always be a little generous. If you are gilding a ¾" (20 mm) wide band for instance, cut the gold into three equal-sized strips as accurately as you can by eye.

Locate the tip of the knife on the cushion in line with the proposed cut. Then bring the edge of the blade down onto the gold and, using firm pressure, slide it forward and back once. Some people recommend that the knife is drawn back right off the leaf so that there is no danger of lifting the gold with the knife, but if you do this the gold can be snagged as the point of the knife passes over it. The knife should cut the gold cleanly; if it does not, or the gold tends to snag, it may be because the blade needs attention.

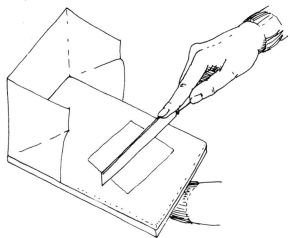

Cutting the gold. The knife is brought down across the gold guillotine-fashion and slid to and fro with firm but not heavy pressure

Laying the Gold

Gold is picked up from the cushion and transferred to the work with a 'tip'. Prepare the hairs of the tip by drawing first one side and then the other across your hair, neck or face so that they pick up a trace of natural body oils. If you have a dry skin, rub a little vaseline or

lanoline on your cheek or on the forearm of the hand which you use to hold the cushion; but beware of making the tip too greasy for then it will not release the gold and the leaf will be torn. Some authorities state that the gold is held on the tip by static electricity. In fact, if a tip does become charged, the gold will leap uncontrollably off the cushion as the tip is brought near to it and will have to be discharged by breathing on it before you can continue.

Take the prepared tip and hold it about ½" (12 mm) above the cushion so that the hairs are parallel with, and exactly above the piece of gold you wish to pick up. Bring the hairs of the tip down in an arc until they contact the leaf and immediately lift them again. There must be no hesitancy or jerkiness; the movement should be a precise one; down—up. If you have cut the gold cleanly and the tip is correctly prepared the leaf will come up on the tip without any trouble, and you can move the gold without any risk of losing it. To enable you to position the leaf on the work accurately, a small edge of gold, about ¹⁄₁₆" (2 mm) wide, should show beyond the end of the tip and at one side of it. Line the gold up with the area you wish to cover and then use the same movement to deposit it that you did to pick it up. Each fresh piece of gold should overlap the previous one by about ⅛" (3 mm), and the gold should be applied so that the overlaps all point the same way. When the tip becomes reluctant to pick up the gold, turn it over and use the other side or regrease it.

While you are using the knife, hold the tip between the fingers of the hand which holds the cushion. Exchange the tip for the knife when you come to work with the tip. Alternatively, when you are not using the knife, you can slide it into the strap which is provided

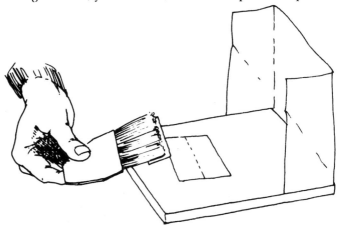

Part of a leaf of gold collected on the tip. The gold projects beyond the edge of the tip to enable one to place it accurately

for it beneath the cushion. In either case, be careful to avoid touching the blade with your fingers otherwise you will have to degrease it before you can use it again.

If you are gilding with whole leaves, they need not be transferred to the cushion but can be taken straight from the book with the double tip described on page 6. This is held by its cork handle so that it can be lowered onto the gold with the hairs exactly parallel with the leaf. If the tip is brought down at even a slight angle the gold will be broken along the line where the under tip ends. This applies equally to picking up the gold and depositing it.

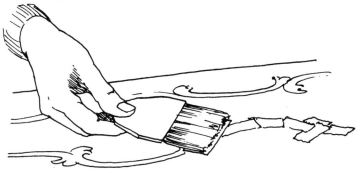

Putting the gold on the work. The hairs of the tip should be as nearly parallel with the surface as possible when the gold is put down

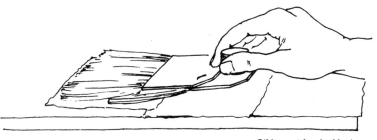

Gilding with a double tip

Pressing the Gold Down

Pressing, faulting and cleaning up need to be done carefully. A few minutes of hasty work at this stage can spoil the effect of hours of careful preparation and gilding. Gold which has been applied with a tip sits loosely on the surface and still needs to be pressed gently into close contact with the size. When you press the gold down, small creases will form in the leaf, but these will disappear when the gold is brushed over during the final cleaning up. The amount you can

gild before pausing to press a section down will depend on the gold size, the weather, what you are gilding and how fast you work. Only if a design consists of very fine lines and has been painted in a fairly quick (3–4 hour) size should it be necessary to press the gold down as soon as it is laid.

Press the gold down, working in the opposite direction to that in which you laid it, so that the overlaps are pressed flat and not ruffled up. It is important to work over the surface systematically because, when you brush up the surplus leaf, the gold may peel off any area that has been missed. Pressing is usually accomplished by patting the gold with a ball of cotton wool, or sheep's wool, enclosed in a piece of clean, finely woven cotton or silk. If coarse cloth is used, its texture can be imprinted on the surface of the gold. Pressing may not flatten all the small creases and will not clean up overlaps, and it is tempting to extend the pressing to a wiping movement to deal with these places. To obtain the brightest surface do not wipe the gold at all, but press it and then brush it lightly with a soft clean mop. A gilded surface can be wiped to finish it, but as the direction of the wiping will affect the way in which the gilding reflects light, the strokes of the cotton ball should all go the same way. If the gold is wiped randomly the gilding will look patchy.

A non-traditional but effective tool for pressing on flat surfaces is a printing roller made of soft plastic. These rollers have the advantage of having a textureless surface, as well as being quick to use. If the surface of a new roller feels slightly sticky, roll it across some rouged sheets from an old book of leaf before using it. Store the roller on its back: if you leave it resting on the plastic it will develop a flat spot.

Pressing gold on mouldings and carved work is discussed at the end of this chapter.

Faulting

Faulting is the term used to describe the process of repairing the gilding in the places where the gold has not taken or where it has broken while being applied. How much faulting will be necessary depends on the type of work and the skill of the gilder, but some faulting will be inevitable. After you have pressed down the gold, but before the size is fully dry, brush the surplus gold lightly to one side and then search for places where the size is showing. Faults are easy to see on a coloured surface when clear size has been used, but if you have used yellow size you will need to look from different directions until you find an angle that allows you to distinguish between the yellow size and the gold. On surfaces where a chalk resist has been applied, avoid brushing chalk onto the gilded parts as it will stick to any size which may still be exposed and make faulting difficult.

If you are using loose gold, cut a leaf into small pieces, and work

your way over the gilding section by section, adding pieces of leaf wherever necessary and pressing them down at once. If the size is almost dry, the gold can often be made to stick if you breathe on the spot before applying the leaf and pressing it down. Usually only small pieces of gold are needed, and as there is a tendency for them to become lost on the underside of a full-sized tip, a piece cut from a tip is often used instead. Alternatively a No. 3 or 4 camel- or ox-hair brush, which has been just damped between the lips, can be used to pick up small pieces of gold reliably and neatly.

It is simple to fault with transferred leaf. Take a sheet of transferred gold and press it on the places where size is showing. Sheets that have only a few fragments of gold left on them can often be used up in this way.

Any faults that are not found until the size is completely dry will have to be repaired using fresh size. A clear size is normally used because it makes a less conspicuous repair than a coloured one, but there will inevitably be a slight change in level, and this will show in the finished work. If the work has been cleaned up and the fault is close to a painted background, remember that you will have to pounce that part again before adding the size.

Cleaning Up

The loose pieces of leaf that are brushed up with the mop are called 'skewings'. Don't throw them away; it is surprising how much you will collect if you gild regularly. Professionals usually sell their skewings back to the goldbeaters. If you only gild occasionally you are unlikely to collect enough to be able to do this, but you can make your skewings into gold powder or shell gold or use them as

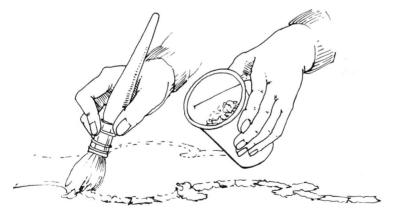

Brushing up skewings. The loose gold can be collected on the hairs of the brush or swept onto a sheet of paper and then transferred to the pot

strewings. Traditionally, skewings are collected in a folded sheet of paper rather like a paper hat, which is burnt to recover the gold, but if you are going to use the skewings yourself, a plastic pot with a snap-on lid forms a convenient container, and a thread stretched across the diameter of the pot just below the top is useful for persuading gold to leave go of the mop.

The gold size will take twenty-four to forty-eight hours to harden once the gilding is finished, and then the work can be wiped with a slightly damp lint-free cloth, a leather or a fine-textured sponge. The surface must not be made wet: there should only be just enough moisture in the wiper to take off the remaining bits of loose gold and any chalk or other resist. Keep turning the wiper to a fresh place and rinse it out frequently. This will leave the gilding clean and brilliant. If you wipe a chalked surface with a dry cloth, you will scratch and permanently dull the surface of the gold.

Removing Gold Size

Although one tries to plan ones work around the drying time of the gold size, there may be an occasion when you misjudge the amount you can gild at one time, or you are called away during a gilding session and by the time you return the size has become too dry. If you apply a second layer of size, the part with the double coat will look different from the remainder when the work is finished. It is therefore better to remove the dried size and start again. Wipe the size off using white spirit, taking care not to smudge it onto adjacent surfaces. Be particular to get it out of crevices and angles in carving and mouldings. The surface should be clean, dry and free from any hairs or bits before you re-size. Pounce the area afresh if the type of work requires it.

Gilding Mouldings and Carving

Because gold sticks instantly to size, it can easily form a bridge across a sharp hollow or an internal angle. Then, when the leaf is pressed down, it will break in an unpredictable way and another piece of gold will have to be applied over the first. It is both slow and extravagant on gold to work in this way, and the professional gilder avoids much of the faulting by concentrating on gilding edges and convex surfaces rather generously and letting the gold overlap in the hollows and internal angles.

A gilder's approach to a moulding, nicely exemplifies this principle of overlaps. Before he starts, he mentally divides the moulding into lengthwise strips which are known as 'lays'. He then gilds the whole of one lay before starting on the next. A lay may consist of one or more members of the moulding, but it will be organized so that sharp hollows and quirks, which would be difficult to gild perfectly with a single piece of gold, come at the

junction of two lays. This means that any breaks left in the leaf after the first run of gilding are automatically faulted by the second. Dividing the work up into lays also has the advantage of allowing the gilder to cut his gold into pieces which are all the same size and to use the same movements when applying each one.

Small mouldings can be more of a nuisance to gild than large ones, particularly if they contain sharp quirks and beads. Some people use transferred gold on them because, by stroking along the backing, they can make the paper more or less correspond with the profile of the moulding. The easiest way to lay loose leaf on small mouldings is to cut a narrow piece from a tip and to use it with its hairs parallel to the run of the moulding. To gild broad shallow mouldings, offer the gold up with the hairs of the tip at right angles to the run of the moulding.

You can tuck gold into a sharp angle with a piece of card instead of a tip. Choose good quality 8 or 10 sheet mounting board which has the same consistency all the way through and cut a piece 3½" (90 mm) square – make it 3½ x 2" (90 x 50 mm) if you want to lay smaller pieces. The cut edges must be perfect with no snags. Grease the edge in the same way that you would a tip and use it to pick up a long narrow strip of gold. Once the gold is bent round the edge of the card it can be placed directly in a right angled quirk, and often no faulting will be necessary. A card which has not been greased can be used in combination with a tip when gilding quirks in a narrow moulding. The gold is deliberately cut too wide and laid with the tip; then the projecting strips of gold are lifted with the card, and turned back on themselves into the quirk. This means that any breaks in the angle of the quirk are repaired without having to be faulted separately.

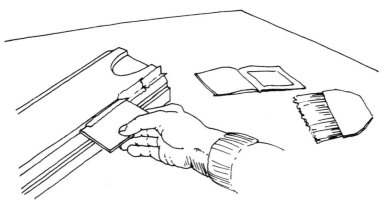

Placing gold in the quirk of a moulding with a piece of card

The gold on the convex parts of carving and mouldings is pressed into contact with the gold size with cotton wool enclosed in a piece of fine cotton just as it is in flat work, but in places where the ball of cotton will not reach, the side of a mop is used. Finally the work is brushed over, but the skewings are not just brushed off and collected; they are used as part of the faulting process. Sweep them gently to and fro across the surface paying particular attention to hollows and crevices where the gold may have split. By the time all the skewings have been used up, the surface will be acquiring a fine polish from the brushing. The deepest parts of carving are often difficult, if not impossible, to gild, and though the yellow size will make these places inconspicuous, they can be improved further by dusting them with some skewings of the same coloured gold saved from another job. Look the work over carefully at this stage because a few pieces of gold may still be needed to complete the faulting. If necessary use a soft paint brush to put small pieces of gold in awkward places.

Part 5. Gesso

Gesso is used to fill the grain of the wood and to provide a hard, smooth foundation for the gold; but to stop the glue in the gesso being absorbed by the timber, the surface is first given one or two coats of glue size. Gesso is always applied on items which are to be water gilded and is sometimes used beneath oil gilding. Gesso is normally brushed on as· a series of coats and though the final thickness may be as little as 1/16" (1.5 mm), it is also possible to build it up into a layer which is thick enough to be carved with elaborate patterns. On old japanned work where paint, gilding and bronze powders were combined, gesso was often used as a foundation. It was also used to create the slightly raised, almost liquid, shapes which are found on some forms of chinoiserie and which were made by trailing the gesso onto the surface with a stick.

In Northern Europe, gesso has been made for many centuries from natural chalk (calcium carbonate), while in Italy, gypsum (calcium sulphate) is the traditional material. In both localities high quality skin glue or parchment size is used as a binder. As in other gilding processes, natural chalk, also called gilders' whiting, should be used – not precipitated chalk.

When objects are to be gessoed, trenails or pegs are better than nails or screws for securing joints. If metal fastenings have been used, and they cannot be punched in and puttied over or pelleted, they should be covered with little pieces of aluminium foil to isolate them from the gesso. If this is not done, rust will eventually cause the gesso to fall off in these places. Before applying the size coat the work should be sanded smooth, and any knots or holes filled with stopping and rubbed down flat.

Glue Size

The best size is prepared by boiling parchment clippings in water in the proportion of 4 oz (110 gm) of clippings to 2 pints (1 litre) of water. There should be plenty of space above the liquid in the pan so that if the size froths up it will not boil over. The clippings should be simmered, with the pan nearly covered, for 1–1½ hours, by which time the liquid will have been reduced to almost half its original

volume. While it is still hot, strain the liquid into a basin to remove the remains of the clippings. When cold the size should be about the consistency of rather soft table jelly. The size will keep well in a refrigerator, but unless it is covered it will gradually lose moisture and it will become difficult to assess the strength of the glue. It should be discarded if it goes mouldy or runny.

If you cannot get parchment clippings, rabbit skin glue can be used instead. Soak 1½ oz (45 gm) of glue in granule or powder form in 1¼ pints (750 ml) of water overnight. Liquefy it by warming it in a glue pot or double saucepan as, like parchment size, once it is made it must not be allowed to boil. Any scum that forms should be skimmed off or it will form lumps in the size coat.

The Size Coat

For the first coat, which is usually called the size coat, you will need a 1″ (25 mm) house-painters' brush; a small filbert hog-bristle brush may be found useful for carving and other awkward places. Warm some of the glue in a double saucepan. The glue may be applied just as it is, but one usually adds just enough chalk to give it a milky appearance and help it to make a firm bond with the gesso. The proportion of chalk is not critical; a rounded tablespoonful in 10 fl oz (300 ml) of size solution is about right. Slide the chalk neatly into the warm size and let it sink to the bottom of the container. When air bubbles have stopped rising, use a brush to stir the chalk gently into the size so that they are mixed thoroughly.

You should apply the size mixture thinly and evenly and with a smooth action to avoid creating air bubbles. Brush along the contours of mouldings and carving, and work the size into crevices so that the surface is covered completely. The size needs to be kept hot over the water bath to give it the best chance of penetrating the wood surface; it also helps if you can work in a warm room. The size coat should be allowed to dry for a minimum of twenty-four hours before you gesso (it may be left for several days to advantage) because the wood will absorb water from the size and expand, and it must be allowed to dry out and stabilize before the gesso is brushed on. If the wood is particularly coarse grained or absorbent, a second coat of size can be applied, and the work left to dry as before. When it is completely dry remove any roughnesses or whiskers which might impair the smoothness of the gesso coats.

The Intelaggio

Structural joins in the piece to be gessoed are sometimes reinforced with strips of cloth. These cloth reinforcements, which are called the *intelaggio*, reduce the tendency of the gesso to crack as a result of movement in the timber. They are applied after the size coats and before the gesso, and are often used over the ends of dovetails, on

carving which has been built up from a number of pieces and in such places as the corners of picture frames.

The cloth used for the *intelaggio* should be well washed and soft so that it will take up the shape of the surface readily but will not shrink. It should be thin, or it will be difficult to cover it with enough gesso to ensure that it does not reappear when the gesso is cleaned down. Open weave or textured cloths should not be used because they can cause air bubbles to form when the gesso is applied. Although linen is the traditional material, in old French work one sometimes finds that silk has been used. Linen or cotton sheeting, which is old and fine, is excellent provided the textile is in good condition. Fabrics made from synthetic fibres can be used on flat surfaces but, though they are strong and do not shrink, they are generally too springy to cling to shaped surfaces well.

Tear or cut the fabric into straight strips when it is to be used on flat surfaces or simple curves, but when covering surfaces that are made up of pronounced compound curves, it is better to cut the strips on the bias, to allow the cloth to take up the shape of the object, and to fray the edges of the strips so that they do not form a hard line. Soak the strips in some of the glue solution you made for the size coat. Then, with your fingers, press the cloth into close contact with the work and smooth its edges. Allow the glued cloth to get thoroughly hard; this will take at least twenty-four hours and possibly two to three days; then cut off any little upstanding hairs or rough edges with a sharp tool.

The Gesso

Take a fresh batch of glue size made up to the same strength as before. Warm it in a double saucepan or a glue pot, and add enough whiting to make the gesso about as thick as single cream. There is no hard and fast rule about the proportion of size to whiting, but as a rough guide, 10 fl oz (280 ml) of size will take sixteen rounded tablespoons of chalk – that is about 22 oz (620 gm). This quantity will make about a pint (600 ml) of gesso. For carving and mouldings the gesso should be about the consistency of thin single cream, while for flat areas the mixture can be a little thicker. You should add the whiting dry, pouring it into the warmed size and allowing it to soak. It is then stirred gently with the brush and the mixture sieved to remove any lumps. The gesso should only be stood over hot water again if it shows signs of gelling. On a hot summer day it will remain liquid for several hours, but in cooler weather it will be necessary to warm the gesso at intervals. If it is left over the heat it will almost certainly fill up with air bubbles which will cause pinholes in the gessoed surface and imperfections in the gilding. Prolonged heating will also result in a ring of dried gesso which will form round the inside of the container and which can flake and drop

back into the mix. At least four or five coats of gesso are necessary as a preparation for water gilding and on flat panels up to nine or ten may be used. Some craftsmen apply extra gesso to the high spots of mouldings and carving, but one needs to be careful not to choke delicate detail with too many coats as this can cause a lot of extra work when one comes to recut the gesso.

Like size, gesso must be brushed on smoothly and evenly to avoid the formation of air bubbles. The first coat or two will dry relatively slowly, but as the thickness of the gesso builds up the coats will dry more quickly. The right moment to apply a coat of gesso, is when the previous one has become dull, and is just firm enough to be coated without being disturbed. If one coat is allowed to dry fully before the next is applied, the bond between them will be poor. This means that you may be gessoing for several hours, and you may find yourself having to work without a break until the job is finished. Large items therefore present a problem because although some pieces can be divided into sections or draped with pieces of damp cloth to slow the drying; the only satisfactory way of gessoing others is for two or more people to work together. Never try to hasten the drying of gesso by raising the air temperature artificially. If you do, cracking is likely to result. Ideally, gesso should be allowed to dry overnight in a falling temperature.

While you are working, the water will evaporate slowly from the gesso in the pot. This is only likely to be a problem in cold weather when, by keeping the gesso warm, you will hasten the evaporation of the water. In these circumstances it is important to stop the glue in the gesso from becoming stronger because, if this happens, the later coats may curl on drying and pull the lower coats off with them. To ensure that the top coats are no stronger than the bottom ones, a tablespoonful of water may be added once or twice during the session.

The amount of gesso that will be needed for a given area will vary depending on the thickness of the mixture, the generosity of the coat and whether the surface is plain or carved. As a rough guide, 8 fl oz (300 ml) of gesso should be ample for 6–7 coats on a flat area of about 4 sq ft (0.3 m^2). Err on the side of making up too much gesso, even if you have to throw some away when you have finished, because it is vital that you should not have to stop to make up more in the middle of a session. A generous amount of gesso will thicken relatively slowly in the pot; it is when there is only a little left that it will dry up quickly and need constant attention.

Recutting and Water Polishing

When the gesso is hard, which it usually is in two or three days, the flat surfaces must be smoothed, and any mouldings or carved parts cleaned up and the detail sharpened. When one is cleaning up

gesso, it is extremely difficult to see irregularities, but once the surface has been gilded and burnished, any erratic reflections will be very noticeable. This is why so much trouble is taken to make the surface of the gesso as perfect as possible. In the first stage, called recutting, the gilder aims to recreate the contours of the underlying surface and he follows this by polishing using damp cloths.

Flat areas can be recut with a stiff, square-edged cabinet scraper. It is held so that it leans slightly in the direction in which it is drawn or pushed. The scraping follows a lattice pattern; first a run of strokes in one direction and then a run which crosses them at an angle. An old method of checking for imperfections was to dust the surface with powdered charcoal; when the scraping was continued, any hollows remained grey.

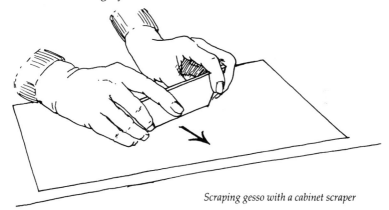

Scraping gesso with a cabinet scraper

A traditional method of cleaning up mouldings was to use wet slips of pumice which had been filed to fit the different parts of the moulding – a modern alternative is to use shaped pieces of wood covered with wet and dry paper. To recut mouldings and carved flutes without wetting them; use short pieces of hacksaw blade which have had their ends sharpened to suitable profiles on a grindstone. These must be used carefully to avoid producing undulations in the gesso.

Each gilder has his favourite tools for recutting carved work. Some scrape the gesso with pieces of modified hacksaw or bandsaw blade while others use engineers' scrapers. If you are a carver, you may prefer to recarve the gesso using tools with shapes similar to those used originally. Whatever you use, the aim is to make the shapes in the gesso as crisp, or crisper than, the carving beneath.

Wet polishing makes the extreme surface of the gesso into a slurry which is pushed into any little hollows which remain in the surface. Take a piece of cotton or linen cloth not less than 12″ (300 mm)

square and damp it by dipping half of it into a basin of water and squeezing out the surplus. Fold the damp and dry halves together, roll them into a bundle and squeeze firmly. This will give you an evenly damp cloth. The cloth may be stretched over your fingers or, if you wish to get a really flat surface, over a block of wood. Shaped slips of wood can be covered with the damped cloth for polishing mouldings. You will need to re-damp the cloth frequently – it is surprising how quickly the gesso removes water from it. If bits start to appear on the freshly wiped surface it is probably because the cloth is beginning to wear; discard it and take a fresh piece.

When polishing with water, do not allow the surface to become too wet or you are likely to blur the crispness that you achieved when recutting. Particular care must be taken with arrises as it is easy to expose the wood, just as it is when you are rubbing down paintwork. When you have finished water polishing, the surface should be as smooth as ivory. Leave the gesso to dry out again for at least twenty-four hours. Areas which will be oil gilded or painted may then be given a coat of thin shellac varnish to reduce the absorbency of the surface.

Muller and slab

Part 6. Water Gilding

To produce a water gilt and burnished surface, the gilder covers the
gesso with several coats of glue size mixed with clay, applies gold
leaf using weak size as the adhesive, and then burnishes the gold
when the work has dried out to just the right state.

Clays

A variety of clays are offered by gilders' suppliers. The colours most
often listed are yellow, red and grey, but one may also find black.
Nowadays the clays supplied by gilders sundriesmen come from the
Continent, and this is relevant because the Continental clays can be
burnished whereas the English clays which were formerly used
required the addition of graphite (blacklead) to enable them to be
burnished.

Whether a piece is to be entirely water gilt or gilded partly in water
and partly in oil, yellow clay is laid on the gesso wherever gold will
be applied. Just as in oil gilding, yellow is a useful colour to have in
the deepest recesses of carving where it is difficult to gild; the colour
tends to blend with the gold and makes ungilded areas and areas
touched up with shell gold, relatively inconspicuous.

Red clay is applied over the yellow clay wherever the gold is to be
burnished. A red burnishing clay is a very finely divided, non-gritty
material: its chief attributes are its ability to flow to form a smooth
surface and to take a fine silky polish. Old English recipes for
burnishing clays sometimes call for the addition of small amounts of
lubricant in the form of suet, tallow, candle wax or soap, which were
intended to facilitate burnishing. Red clays, although not strictly
pigments, may have considerable tinting strength, and can range
from a fine translucent orange – like the traditional Armenian bole –
through to the colour of burnt umber. English clays were usually
reddish in the pure state but, depending on how much graphite was
added, they could become a slightly darker red, a deep plum or even
a slate colour, and one sometimes finds these colours on old work. A
good red clay imparts a fine warm glow to a gilded object, and when
the surface becomes a little worn, or if it is distressed, the colour
which shows will be sympathetic to the gold; but if the clay is very

42

dark, the colour which shows through the gold will be heavy and unpleasant.

Today there is some confusion about the use of grey clays, but it seems likely that in the past they were intended to be used beneath tin and silver leaf. In old recipe books, grey clays are sometimes called 'silver size', and it is often suggested that they should be made by adding lampblack or blacklead to a white clay. The ready mixed grey clays which can be bought today are suitable for use beneath any of the white metal leafs including white gold and silver.

Many gilders use clays that have been dispersed in water to form a soft paste; these are convenient as they save time in preparation. However, some gilders still prefer to buy their clay in dry, cone-shaped lumps and to grind it themselves, because then they know exactly how much water has been added when they come to mix it with size. To convert dry clay into a paste, scrape some clay off the cone with a knife and mull the powder with water on a slab. Traditionally both muller and slab were made of stone, but a perfectly satisfactory slab can be made from a piece of plate glass at least ⅜" (10 mm) thick by 16" (400 mm) square, and which has had one side toothed with a medium valve grinding paste or 320 grit wet and dry paper. The muller should be large enough to be held comfortably and should have a perfectly flat ground base, which is not less than 2" (50mm) in diameter. (The base of a new muller may need to be ground flat.) If you do not have a muller, a good quality kitchen palette knife can be used instead. To convert the bole and water into a fine smooth paste, mull it using a circular motion and plenty of pressure. The best way to prepare the bole is in small batches; collect up each batch and put it into a covered container as soon as it is ready, so that no dust or lint gets into it.

Making and Applying Bole

To make the yellow bole, take five or six parts by volume of the size that you made for the gesso, and one part of yellow clay paste. Warm the size over hot water; place the clay in a basin and add a little of the size to the clay gradually. Stir until the paste is well dispersed and liquid, and then add the rest of the size. This bole should be about the consistency of milk, and should flow readily from the brush.

The best brush for applying bole is a round, sable water-colour brush. The size of brush depends on the scale of the work; for ½" (12 mm) mouldings, a No. 4 or 5 is about right, and even for quite large areas a No. 7 or 8 will be perfectly adequate. Use the bole as soon as it is made up, as the longer it stands about, the more likely it is to collect dust and hairs. If the size cools to the point where it begins to thicken, the basin can be stood over hot water again for a

moment or two, until the mixture becomes liquid. Don't leave it on the heat, as this will hasten the evaporation of the water, and alter the strength of the size in relation to the other coats. Like gesso, bole can become full of air bubbles and can dry around the sides of the basin if it is left on the heat for too long.

Immediately before applying the bole, dust the work off carefully with a squirrel-hair brush to remove any gesso powder, bits of cloth, hairs etc. Cover the basin of bole, or put it well out of the way, while you do this. From this stage onwards one cannot be too particular about keeping dust off the work.

Coat the work with the yellow bole as evenly as you can, putting it on with smooth strokes that do not overlap one another and which follow along mouldings and the contours of carving. If you miss a place, don't try to repair it while the bole is still wet as you will only disturb the surface. Try not to trap air bubbles in angles and crevices. This first bole coat is the most difficult one to apply smoothly because the gesso will absorb the water from each brushful almost instantly. Normally, only one coat or at the most two coats of yellow bole are applied.

Red bole is made in the same way as yellow except that less size is used – three or four parts of size to one of bole paste. When mixed with the size, the bole should be about the consistency of single cream. If in doubt it is safer to make it slightly too thin rather than too thick, because bole that is too thick will brush on unevenly and make ridges that will have to be ground off later. The number of coats of red bole varies with the quality of the work; two are the least that should be put on, but on fine work it is not unusual for four or five coats to be used. Allow each one to become just dry before applying the next.

After the last coat has been brushed on, leave the bole for twenty-four hours to harden before you grind off any irregularities with the finest grade of flour, emery or garnet paper. You can reduce the cut of flour paper by rubbing two pieces together face to face. While you are rubbing down the bole, you will discover whether the surfaces are really flat because any high spots will become dark and glossy almost immediately, but hollows will remain light in colour. Some people like to apply one last coat of bole after rubbing down, but this is only essential if you have cut through the bole anywhere.

When you have finished rubbing down, dust the work off carefully; rub the surface vigorously with a soft, absolutely clean, bristle brush and then dust it off again. As an alternative to 'bristling' some gilders burnish the surface with agates. Burnishers used for polishing bole should be kept exclusively for this purpose as they will inevitably become scratched and then are not fit for burnishing gold.

Applying the Gold

Some gilders coat the bole with thin size, allow it to dry and then use plain water when they come to gild. Others add size to the water they use to attach the gold, but many prefer a mixture of water, size and alcohol. This last version of gilding 'water' produces the most reliable results, particularly if you are not an experienced gilder, as the alcohol overcomes any tendency of the water to bead on the bole. It is made as follows: take a lump of the size as large as a hazelnut and dissolve it in 4 fl oz (100 ml) of water in a clean cup; then add 1 fl oz (25 ml) of alcohol. In the eighteenth century brandy or gin was sometimes used; today some people recommend ethyl alcohol, but iso-propyl alcohol is equally good and is much less expensive in England as it is not dutiable (methylated spirit with its blue dye is not suitable).

Arrange the work so that the surface you are gilding is on a slight slope to ensure that the water cannot run back over the gold you have laid. Lay out a leaf of gold on the cushion and cut it into whatever sized pieces you need; pass the tip through your hair; pick up a piece of gold and put the tip with the gold on it between the fingers of your cushion hand. Then with a clean sable water-colour brush wet an area at the top of the slope that is a little larger than the space which the piece of gold will occupy. The surface must be wetted generously, and you will probably have to pass the brush over it twice as the bole will take up the water quickly to begin with. The surface should have a thin film of water standing on it when the gold is put in place because if parts of the surface have already become dull there is a good chance the gold will not stick. The gold needs to be laid with the same kind of smooth, down—up movement that one uses for oil gilding. The gold will be pulled off the tip by capillary attraction the instant it touches the water so the tip must be almost parallel with the surface when the gold contacts it. If the leaf is offered up hesitantly or at too steep an angle it will probably become torn or folded; if this happens, take it off immediately with a wet brush and try again with a fresh piece. To lay the next piece; pick up the gold and put the tip back between the fingers of the cushion hand; then wet the surface of the next area, and gently pass the brush just over the edge of the first piece of gold without disturbing it. Lay the second piece so that the part which overlaps the previous leaf covers a little more than the wetted area. If it does not, when the work has dried, you will find a watermark on the gold which cannot be removed. Pick up another piece of gold, wet the next area and proceed as before.

If you watch the surface of a piece of gold which you have just laid, you may see that there are bubbles beneath the gold. These are of two kinds: water bubbles, which flatten out in a few seconds as the water is absorbed, and air bubbles, which remain after the others

have flattened and which need to be pressed down to ensure contact between the gold and bole. The only problem is deciding when to press the leaf down with the mop to ensure that these bubbles and any small folds come into close contact with the bole. The surface beneath the gold must not be dry, but neither should there be free water present which could break through the gold and spoil it. In practice the first piece is likely to be ready to press down after you have laid two or three more pieces, but exactly when you go back to press the gold down will depend on the speed at which you gild.

There is nothing particularly difficult about laying gold on flat surfaces, but when one comes to gild mouldings and carving, greater skill and different techniques are required. A convex area such as a bead can be gilded with a single piece of gold which will fall into folds in adapting to the shape. For a concave area use two or three pieces of gold to reduce the curvature required of each piece. When you are gilding around the edges of raised decoration, such as foliage or strapwork you will find problems which are similar to those encountered in oil gilding. Avoid applying the gold so that it sticks to the high spots and bridges the hollows beneath. Arrange that the pieces of gold are large enough to lap over the edge and down just into the angle where the side of the decoration meets the ground. If the capillary attraction of the water is not sufficient to pull the leaf into an internal angle, immediately ease the leaf into place with the side of a dry sable paint brush or a small mop using *very* gentle pressure. The gold will slide on the cushion of water beneath it, but do not poke with the end of the brush as this will only puncture the leaf.

Double Gilding

Today, as in the past, when top quality work was always double gilt, the best results are obtained if surfaces that are to be burnished are covered with two layers of gold. Usually extra, or double weight gold is used for this, as the finish achieved is much richer than if single weight is used, and today, except on large scale work, the extra cost of the gold is insignificant compared with the cost of the gilder's time.

When you intend to double gild a piece, try not to touch the surface during the first gilding as any grease can cause the second application of gilding water to bead. If you cannot avoid handling the work, wear cotton gloves. The strength of the size is critical when double gilding. Beading can occur if the size is too weak, and conversely, if the size is too strong, or the room not warm enough, the size can gel in the hollows.

Apply the second layer of leaf as soon as you can do so without disturbing the first. Work over the surface in the same order as you did when you gilded it before, but wet it less generously because the

gilded surface will not absorb any water. Avoid passing the brush over any part of the gold more than once or you may disturb what you have already laid. Each leaf will still need to overlap the previous one, and you will still have to find out by trial and error how long to leave it before pressing it down.

Faulting

Although some parts of the water-gilding process are laborious, small faults can be repaired much more easily and inconspicuously than they can in oil gilding. A professional gilder seldom needs to do much faulting, but it requires a lot of practice to acquire the kind of skill in handling gold leaf that will ensure that leaf after leaf is laid perfectly. After the gilding is finished and you have swept the work over lightly with the mop, you may find a few water stains and some spots of bole where little pieces of gold have become dislodged. In places where the bole still shows, damp the spot and the area immediately surrounding it with gilding water, apply a piece of leaf and press it down at once. To cover water stains, breathe on the part so that the moisture just condenses on the metallic surface, cover the mark quickly with a piece of leaf and press it down. Fault each area with a piece of leaf cut to allow a generous amount to spare all round – it is always a mistake to use too small a piece of gold. Press the gold down with a ball of cotton where you can, and use the mop where the cotton ball will not reach. When there are many breaks in the gold it is quicker to gild the whole surface again than to fiddle about dotting the work all over with little bits of leaf.

Burnishing

Burnishing is the slowest part of water gilding, and as the work only remains in a state when it can be burnished for a few hours, it will be seen that the amount that can be burnished in a day determines how much gold is applied at one time. Convex and flat surfaces are burnished with burnishers which are slightly convex, while concave ones, such as flutes, are worked with the burnisher that most nearly fits the curve.

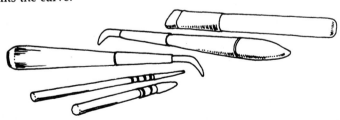

A group of burnishers. The hooked ones are the traditional dogs' tooth shape

The time which needs to elapse between gilding and burnishing varies with the temperature and relative humidity of the workroom. In some parts of the world gilding can be burnished in two or three hours while in others it may still not be ready at the end of two days. In ideal conditions, one day's gilding can be burnished on the next. Most gilders say that if the gesso makes a sharp click on being tapped with the burnisher, the surface is dry enough to be burnished, and that if the sound is dull the gesso is too damp. However, it takes some experience to know just what the sound should be like and, if you are not sure, it is safer to leave the piece until it is slightly on the dry side. If you burnish when the gesso is rather dry the work will be harder and slower than it should be, but it will still be quicker than having to repair the damage caused by burnishing too early.

You can also tell whether the surface is dry enough to burnish from its feel; if the burnisher runs smoothly and shows no tendency to stick, the surface is probably dry enough. To burnish; run the agate lightly over the surface to begin with, so that it hardly affects the brightness of the leaf; then increase the pressure a little with each successive stroke until the agate leaves a shining path in the gold. A well burnished surface should look as if it is made from highly polished solid metal, but as the brilliance of the burnish depends upon the state of the gesso, one should burnish an area or feature as an entity so that the whole part is brought to the same degree of burnish. If one starts by burnishing a small part very highly, it may not be possible to make the rest of the area match it. To reduce the friction between the gold and the burnisher, wipe the work over with the thinnest possible film of plain furniture wax. Rub it off with a soft, clean cloth when the burnishing is complete.

To prevent the work from being accidentally scratched by buttons etc. wear a clean apron of soft material. If you have to hold small items, such as finials, in your hand while you are burnishing them, hold them in a cloth or wear a pair of cotton gloves, because if your hands become hot they can stick to the gold and damage it.

Bright and Mat Gilding

Burnished water gilding is often combined with passages in mat gold. The mat effect is normally obtained by leaving some of the water gilding unburnished, but in the past oil size was sometimes used to attach the gold in places which were to be left mat. In the former method, the unburnished gold is usually made more mat with a very thin coating of shellac varnish known as 'ormolu' (not to be confused with ormulu), which should be applied with a soft brush as evenly as possible. Oil sized areas are not usually coated with ormolu because there is some risk that the alcohol in the varnish will soften the oil adhesive and cause the gold to be picked

48

up on the brush. The traditional size for matting oil gilding is made from one part of parchment size, made like that used for gesso, and diluted with two parts of water. Use de-ionized water in hard water areas and brush the size mixture on very thinly while it is still warm.

Water Gilding Combined with Paint

Work which is to be partly water gilt and partly painted is normally gessoed all over, though where the paint will be applied the ground need only be just thick enough to fill the grain of the wood. The gesso is smoothed in the usual way to provide a good surface for the paint.

Paint is always applied after the work has been gilded and burnished because, although one needs to be careful not to get paint onto the gilded parts, the paint can be used to create a clean edge and cover the ragged outlines of the bole and gold leaf where they lie on the gesso. Paint which dries to a mat or eggshell surface is normally used as gloss paint does not have sufficient covering power. It is an advantage if the paint flows to a smooth surface, but even if it dries with slight brushmarks, it is better to leave them than to risk damaging the gilding by rubbing the paint down. In spite of being thinly coated with shellac varnish the gesso may absorb oil from the paint, and as a result the paint may dry to a more mat surface than you expect. If you feel that the effect is too mat, the surface can be varnished or wax polished when the paint is dry.

A pricked design

Part 7. Special Techniques

Transferring Designs

Patterns can be created in gold in two ways: you can oil gild on paint, or paint after you have water gilded. In either case it is usually necessary to set out the design. The most direct way is to draw on the chalk-dusted surface with 'stump' – the pointed roll of paper which artists use for blending pastels. This method does not give a very precise line, but where features only need to be broadly indicated it is perfectly adequate. When accuracy is important, first make a full size drawing on paper. If the design will be required only once, use a light-weight paper such as draughtsman's detail paper so that you can transfer the design directly from the master drawing. If the design is to be used repeatedly, it is better to make a photocopy or a tracing of the master drawing and to use that for the transfer.

The most basic method of transferring a design to a painted surface utilizes the dusting of chalk that one needs to apply, in any case, as a resist for the gold. Apply an even layer of chalk by patting with the pounce bag all over the area to be decorated. Then position the design on the work and hold it in place at one edge with drafting tape or weights. Lift the free edge of the drawing and slip fresh, typists' carbon paper (not dressmakers' carbon) beneath it. Trace over the design with a hard pencil such as a 4H or 6H, but don't press too hard or you may indent the surface of the paint. Where you draw, the chalk will stick to the slightly greasy carbon and when you remove the paper, the lines of the design will show clearly in the chalk-covered surface. After the carbon has been used several times it will need to be wiped with tissue to remove the surplus chalk. This method of lifting out the lines works well on bright and rich, dark colours, but on pale and pastel-coloured grounds, where the contrast between the ground and the chalk is low, it is better to use chalked paper to transfer the designs. Rouged paper is available commercially but the home-made version is less messy to use. To make chalked paper, take detail paper or typists' thin copy paper (flimsies), and rub one side of it with the flat of a reddish or brown *conté* crayon. Rub the colour well into the paper with a pad of tissue

and then shake off the loose dust. Slide the chalked paper beneath the design, chalk side down, and go over the outlines with a pencil. The coloured chalk will offset onto the paint even when the surface has been dusted with the pounce bag. If you prefer to pounce afterwards the design will not be smudged.

Colour on carved and water-gilded objects is usually applied to emphasize the form, so the details of the carving dictate where the paint is put. On flat water-gilded surfaces, where it is important to avoid indenting the gold, the design should be transferred with a 'pricking'. This method can also be used on painted surfaces. It is particularly useful for transferring a repeating design because, though it may take some time to make the pricking, the actual process of transferring it is quicker than drawing over an outline again and again. Because the pricking becomes covered with chalk, it is advisable either to make a tracing of the design and prick this, or prick through the master drawing into a sheet of paper placed underneath. It is an advantage to have a generous border round a finished pricking so use a sheet of paper which is amply large. Take a No. 8 or 10 sewing needle and push its eye into a cork so that it is comfortable to hold. Then work along the lines of the design, pushing the tip of the needle vertically through the paper and into a cork or felt backing. The distance between the pierced holes depends on the scale of the design; for fine detail the holes should be 1–2 mm apart. Hold the pricking in position on the work, and brush or rub finely powdered charcoal or dry raw umber through the holes. Sweep the colour to and fro; do not pat, or the paper will be bounced up and down and the colour dispersed. Lift the pricking carefully off the work, and you will find the lines of the design formed of little dots of colour.

Lettering

The technique of gilding a name or an inscription is similar to that used when gilding a pattern. However, the arrangement of the words, and the drawing and spacing of the individual letters pose some special problems. If the inscription will comprise more than one line, make thumbnail layouts to decide where the line breaks should occur. Bear in mind the length of the words, the sense and the way the block of lettering will relate to the shape of the panel. Then draw out the inscription at full size on detail paper.

If an inscription runs to more than one line, and one has less space between two successive lines than there is between two words on the same line, the eye tends to be drawn up or down to the nearest word instead of along the line. When you set out inscriptions which contain both upper and lower case letters, allow sufficient distance between the lines to prevent the descenders of one line from coming too close to the ascenders of the line below.

Equally important, if the lettering is to look balanced and of an even density, is the amount of space allowed between both the words and adjacent letters. In traditional printing each letter is moulded as part of a metal block which is a fixed width for that letter and type size, and the widths of these blocks regulate the space between any pair of letters. For the sizes of type found in books, this is a perfectly acceptable solution. However, when the letters are large, and particularly if only upper case letters are used, awkward gaps occur between some pairs of letters. If you print an alphabet of capital letters you will see that many of them occupy most of their allotted rectangle: B, G, H, I, M, U & Z for example. The awkward letters are: A, F, L, P, T, V, W & Y. If your inscription contains a letter pair such as 'TA', a certain amount of adjustment can be made by slipping the foot of the 'A' slightly beneath the cross bar of the 'T', but in the case of a combination like 'LA' this is not possible because the feet will touch before an appreciable effect can be made on the space between the letters. In practice, the pair with the largest space between them governs the spacing of all the remaining letters on the line. A pair such as 'ND', will need to be moved further apart than a pair like 'DO', because the two verticals are denser visually than two curves. The open letters, C, G, & E, more or less fill the basic rectangle, but because they are not totally enclosed, their internal area tends to read as part of the intervening space. Spaces

GILDING

GILDING

The spacing of the upper word has not been adjusted and contains large variations in the density of the strokes. Notice how much less obvious the gap between L and D has become after spacing

GILDING

GILDING

In the example neither word has had its spacing adjusted, but the uneven density is much less obvious in the open letter version

between words present much the same problems. For example, the gap between a word ending with 'P' and one beginning with 'Y' will need to be closed up if it is to look the same size as the space between a terminal 'M' and an initial 'E'.

Besides adjusting the spaces between letters, one is likely to have to modify their height. Many of the letters in an upper case alphabet fit exactly between parallel lines, but curved letters, such as O, G & C, should be made to *just* cross both the upper and lower boundary lines. If this is not done, these letters will seem slightly smaller than those which have serifs on the line. Similarly the points of A, N, V & W, are elongated so that they cross the setting-out lines by a fraction.

If you shade the inscription neatly, it will help you to assess the density of the lettering. It is much more difficult to judge whether the spacing is right when the letters are drawn in outline only. Look critically to see whether any words tend to fall apart because of excess space between particular letter pairs.

The easiest way to respace a line of lettering is to take a clean sheet of detail paper and draw a pencil line on it that is the length of the finished inscription. Now take your shaded drawing and draw a register line just below and parallel with the letters. You can now cut between any letters that need to be respaced, and arrange the pieces at what you consider is the right distance apart. Line the letters up with the pencil line on the detail paper, making sure that the register line is straight and then tack the pieces of the inscription into place with drafting tape. You can adjust the spacing as many times as you wish, and large or small alterations can be made without the trouble of rubbing out letters and redrawing them. When you have spaced the letters to your satisfaction, trace them onto another piece of detail paper and use this as the master.

Drawn and painted lettering should not look mechanically hard. The ends of the vertical strokes should curve in very slightly, and the long 'straight' lines should be formed of sweeps which are not quite straight. This does not mean to say that the lettering should be lumpy with uneven serifs. It needs to be balanced and should have the kind of liveliness about it which is lost when the lines are drawn with a ruler or other mechanical aids.

When you paint letters, always use the tip of the brush to define any point or serif, and draw the brush inwards over the body of the letter. Then use the length of the hairs to paint the smooth curves and lines which form the body of the letter much as you would when painting long lines.

Lettering which is in upper case may be shaded or outlined to help to separate it from its background and to give it greater impact. The shading may be on the letters or it may take the form of cast shadows on the ground. If you wish to shade, decide, when the

lettering is still at the sketch stage, at what angle you wish the shadows to be cast, and check whether it will cause any problems with letters containing sloping lines. You will need to allow extra space between the letters for the shaded area. If you outline the letters you must decide, again at the sketch stage, exactly where the outline is to go – on the letter or on the background – otherwise the letters may end up looking disproportionately thin or unnecessarily coarse.

ABDEON

ABCDEM

Some examples of three-dimensional effects in lettering

Gold Powder and Shell Gold

Powdered gold can be made by grinding either skewings or leaves of gold with a little clear honey. In some old books it is suggested that this should be done in a mortar, but a muller and slab gives a better result. The honey adheres to the leaf, the slab and the muller, so that as the muller is moved the leaf is torn into smaller and smaller pieces. Half a teaspoonful of honey is enough to break down a heaped tablespoonful of uncompressed skewings. Use the muller and slab described in the section on clays, and work the muller slowly, but with considerable pressure, in expanding spirals so that the gold–honey mixture is spread out thinly on the slab. Then scrape it up with a palette knife and start again. The skewings will break down quickly at first, but you will have to continue to mull for ten to fifteen minutes because the longer you grind the finer the powder will be. When you have finished mulling, the honey will have to be washed out. Transfer the brown mixture to a drinking glass with barrel-shaped sides and fill it with hot water. When the gold has settled, carefully decant the water into another vessel so that you can recover any gold that you accidentally pour out. Repeat this five or six times using de-ionized water for the last two washings; then allow the gold powder to dry naturally.

A tablespoonful of skewings will only make about ⅛ dwt (0.2 gm) of gold powder, but it is about as much as one can separate in a glass and, as gold powder is difficult to obtain, even this quantity can be worth making. Double-weight leaf produces a brighter powder than single weight, but the behaviour of the gold

powder also depends on the size and shape of the particles. If they are too small, the effect is dull, but large particles tend to hang together and form clumps when you try to use them. If you want to convert your gold powder into paint which you can use instead of a commercial gold tablet, mix in one drop of concentrated gum arabic solution when most of the water has evaporated from the gold. Traditionally, gold paint was kept in mussel shells and this has given rise to the name 'shell gold', but any small container will do.

Strewings or Spangles

As well as being converted into powder, gold skewings can be used to decorate a painted surface with fragments of metal which are known as strewings or spangles. The technique was first used on oriental lacquer, and was copied by European japanners of the seventeenth and eighteenth centuries. However, its use need not be confined to chinoiserie decoration, and spangles are particularly effective when used on dark or richly coloured grounds.

If you collect skewings to use as spangles, you should keep your yellow and white gold skewings separate. To use the skewings to spangle a surface, you will need a sieve. This can be a domestic sieve or you can make one by cutting the base off a small plastic pot and fixing a piece of net or gauze firmly in its place. The size of the holes in the sieve will control the size of the fragments of gold which drop through, and it is worth experimenting with different meshes on a test area of gold size to discover what effects they produce.

The area to be spangled is coated with clear oil size and when the size has achieved the degree of tack which would be right for gilding the gold is dusted on. Gold size on its own will make the surface very shiny and you may prefer to dilute the size with an equal volume of white spirit so that the surface dries mat. If you dilute the size in this way, you will shorten its drying time considerably, but it will still have sufficient tack to hold the metal fragments. Put a small pinch of skewings in the sieve – more will make it difficult to control the density of the dusting – and brush them about on the mesh so that some fall through. Start by applying a very light dusting and then pat the spangles down with a mop. This will flatten any particles which landed on edge, and the strewings will probably appear denser than you expected. It is easy to add more strewings if they appear too sparse, but if they are too dense, the size will have to be taken off and the work begun again.

You may need evenly spangled grounds or areas where the dusting is graduated from dense in one place to sparse in another and, with practice, a sieve can be used to produce either of these effects. When a spangled ground is perfectly dry it can be dusted with chalk or coated with egg-white resist, and other detail such as patterns, plants, figures etc. can be added.

Metal Powders

Bronzes and gold powder may be used on their own, combined with leaf or glazed with colour to create decorative effects that cannot be produced with leaf alone. There are two approaches to applying dry powders. Precise shapes can be painted with the size and covered with powder, and the result will be well defined – even hard edge. Alternatively the entire area can be coated with clear size, and the metal powder applied, usually through a stencil, to make shapes with precise or softly shaded edges. Decorations in bronze or silver powder need to be varnished to protect them from oxidation, but if this is done they will retain their brightness for a long time.

When metal powder is to be brushed onto shapes painted in gold size, the surface should be dusted with the pounce bag or an egg-white resist should be painted on before the gold size is applied. The size can be coloured to make the metal appear more solid – add a little pale grey oil colour to clear size for aluminium or silver powder, yellow for the gold-coloured powders and light red for the copper shades. The powders are brushed onto the work when the size is a little tackier than would be right when dusting skewings from a sieve. Remember that fine detail painted in size will dry faster than large masses.

As soon as all the size on one part of the design has been covered, the metal powder should be firmly pressed into the tacky size to ensure that as much as possible adheres. If one pats directly with a cotton ball, powder can be transferred from one place to another. This problem can be avoided by laying a piece of smooth paper (ideally silicone release paper) over the area and pressing on it either with the cotton ball or a roller.

If you are working with more than one colour of bronze in a session, keep a separate brush for each colour. When putting on different colours side by side, use small brushes and ensure that the sticky mordant is completely covered with powder so that no other colour can adhere to it by accident. Extra care is needed when using aluminium powder, and burnishing and lining bronzes which are all so fine that they can become ingrained in the decoration on an adjacent area. In general, the coarser the powders one uses the less trouble one is likely to have in this respect and also the more lively and interesting the surface will be.

In the past shaded effects in bronzes or gold powder were used in the decoration of painted furniture as well as *papier maché* and japanned iron items. In this type of work clear size was painted over the whole of the area to be decorated and the design was built up from individual shapes produced with templates or stencils. The stencils were cut in stiff paper which had been treated with linseed oil and allowed to dry. If you want to try this technique, choose a slow size so that you have plenty of time to piece the design together

and start to apply the metal when the size is in the right state for gilding. The powders will stick without any separate pressing because, when the surface is only lightly dusted, each particle will be in contact with the size; whereas with heavier applications, many particles will be lying wholly or partly on others. The metals are not applied to the sized surface with a brush but with a variety of small tools which are lightly charged with the powder. Large areas are usually bronzed with a velvet pad called a 'bob' while for small areas twists of wool or chamois are fastened round the ends of sticks or brush handles. Quills or tubes with little pads of leather or felt fitted into their ends are used to dab dots, draw lines and shade other precise, but soft edged, shapes on the barely sticky size. When a graduated area is to end in a well-defined edge, the template or stencil is held firmly against the surface while the powder is applied. Begin at the edge of the cut-out shape and brush either out across the size or along the edge of the shape so that the density of the dusting is graduated and becomes lighter the further one is from the stencil. It is better to have too little powder on the bob than too much because if the bob is overloaded it becomes difficult to control the powder.

When the size is perfectly dry, the surplus powder can be wiped off with a barely damp sponge or leather in the same way that gilding is cleaned up. If one varnishes using a brush it is essential to remove all loose powder because any surplus can become smeared during varnishing. Alternatively, the varnish can be applied using a spray.

You should avoid inhaling bronze dust. So if you use bronze on a large scale or work with it regularly, it is advisable to wear a mask when applying it, and to ensure that any powder which is lying about in the studio is kept to a minimum.

Schlag Leaf

Although it is much thicker than gold leaf, schlag still needs to be handled in a special way so that the sheets do not become torn or creased. When you open the pack, put the end leaf or two on one side; they will probably be too discoloured to use already, but if you replace them when you put the pack away they will stop the other leaves from becoming tarnished. Either coloured or clear oil size can be used as the mordant. The leaf should be applied when the size is slightly tackier than would be right for gold. Transferred schlag, like transferred gold, is cut with chalked scissors. Loose schlag should be cut in the same way; it is too thick to be cut with a knife, and a leaf is too big to fit comfortably on a cushion.

It is easy to pick up transferred schlag by its backing and apply it to the gold size. A well greased badger tip can be used to lay cut pieces of loose schlag on vertical and shaped surfaces. Both whole

and part pieces of loose schlag can be laid on horizontal surfaces from a piece of card. Choose stiff, smooth card and cut the edges cleanly so that there are no roughnesses to snag the leaf. Make the card the width of a leaf one way and at least an inch longer in the other direction so that you can hold it comfortably. A gilders' knife can be used to pick up the schlag and move it to the card, or a corner can be lifted with your fingers and the card slid underneath. Arrange the leaf on the card so that a strip about half an inch wide hangs over the end. The card is lowered towards the work until the leaf touches the sized surface, then the card is gently withdrawn and the leaf pressed into good contact with the size using the ball of cotton. The leaves should be laid with overlaps. Clean the work up as if it were a piece of gilding, but do not bother to save the skewings. This type of leaf must always be varnished to prevent it from tarnishing. Suitable varnishes are discussed in part 8.

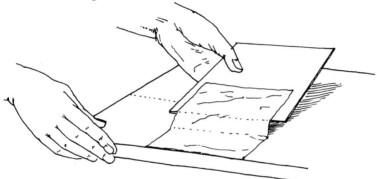

Sliding schlag leaf off a piece of card onto the sized surface

Metal and Colours

Some of the earliest examples of the use of paint on water gilding occur in paintings of the medieval period. At this time the opaque colour coats were usually painted in egg tempera, a medium made from pigment mixed with yolk of egg. This could either be used to paint a pattern on the gold, or the gold could be covered with solid colour and the pattern created by scratching into the partly dry paint. When dry the pattern could be glazed with colour ground in oil. Rich and finely detailed effects, particularly in the rendering of textiles, were obtained in this way. Egg tempera sticks to gold well and eventually forms a very tough surface, but it dries slowly, and unless you can leave it for several months so that it can harden completely, it is not practical to use it on an object which will be handled.

When the process is reversed and the metallic decoration is applied over a coloured ground, oil gold size is used to attach

whatever type of leaf or powder is chosen. Fine examples of this technique are to be found in the European imitations of Oriental decoration that became known as chinoiserie. However, one also finds both furniture and harpsichord cases in the baroque and rococo styles decorated in gold on a coloured ground with such motifs as acanthus ornament and festoons of flowers.

A ground can be any colour, but those which contrast most successfully with metals are the dark and strongly coloured ones. Pale cool colours such as blues and greens also provide a good contrast, but warm pale colours like yellow, buff and ivory are too similar in tone to gold, silver and bronze to read well at a distance. Vermilion grounds are successful with gold leaf but less so with bronzes because the metal powder is insufficiently reflective. The ground need not be a plain colour. Sometimes simple gold decoration was added to surfaces painted in imitation of such things as tortoiseshell, lapis-lazuli or malachite.

Variety and richness may be given to metals applied on a painted ground by using coloured glazes as well as by adding outlines and internal detail in opaque paint or Indian ink. Glazes are seldom used over bronze powders, and when they are applied on top of metal leaf they must be extremely thin so that they reduce the brilliance of the leaf as little as possible. The gold size beneath leaf and bronzes must be thoroughly dry before any glazes, particularly alcohol-based ones, are applied. (The Pigments which can be used in glazes are discussed at the end of this section.) Areas of both leaf and bronze powder can be defined by outlining them. This is a useful technique when the contrast between the leaf and ground is low. Outlines also provide a way of giving some parts of the design more importance than others. They need not be in black; coloured outlines can be effective, particularly where polychrome and metallic effects are combined, or where the design is on a neutral ground such as pale grey. Internal lines can be used to suggest form – the roundness of tree trunks, or the cragginess of rocks – and to add details such as features on faces and veins in leaves. Pattern often plays an important role in adding richness to outlined, leafed and bronzed decoration; trellises, clothing and repeating groups of foliage and flowers are typical of the motifs which can be enriched in this way. Another use of paint on metal leaf is to create areas of either constant or graduated tone in which a thin layer of opaque or semi-opaque paint partially masks the leaf. When *trompe l'oeil* effects are aimed at, the shading is often extended onto the ground in imitation of cast shadows. All these techniques need to be used with restraint or the effect will be fussy and overcrowded.

Silver or tin leaf was sometimes laid beneath real tortoiseshell to increase the amount of light reflected through the shell. Another practice was to paint the back of the shell with vermilion to make the

colour of the tortoiseshell richer and more lively. When the shell is to be imitated in paint, either leaf or vermilion may be used as a ground. The white metal leaf is thinly and unevenly glazed with red and brown oil colour which has been diluted with turpentine. Once the glaze is dry, groups of round and oval spots of differing degrees of opacity are dabbed on with a soft round brush using oil colour mixed with a little varnish. The work may be covered with further reddish glazes before more spots, which partially cover the earlier ones, are added to get a soft, complex effect. When a vermilion ground is used, the tortoiseshell is imitated in a similar way but the spotting will need to be mostly in different densities of black mixed with raw umber. It is a help if one has a piece of real tortoiseshell to refer to for the distribution of the markings, though the colour of the light parts of the shell is usually yellow rather than red.

The appearance of patinated bronze can be imitated by mixing combinations of raw umber, black, yellow ochre and terre verte with the varnish which is applied on top of the bronze coat. The characteristic dry, powdery surface of the corroded metal is usually imitated by patting dry pigment into crevices and onto textured areas while the varnish is still tacky. Thinned shellac varnish is useful for patination effects because it dries quickly, and so allows work to be continued almost without a pause.

Newly gilded surfaces are sometimes 'distressed' by rubbing them with fine abrasive powders mixed with wax to cut through to the bole in the places that would naturally become worn. To give the effect of age and grime, ormolu to which a little raw umber has been added, is applied to the surface with a brush or rag. One needs to think carefully about which areas are to be distressed or darkened, or the result can look artificial. The grey dust which accumulates in crevices is usually imitated with grey rottenstone, which is more convincing than pigment because it has a coarser particle size. The crevices are first coated with varnish; the dry rottenstone is brushed on while the varnish is still wet, and the surplus is brushed off when the work is dry.

Except when dry pigment is required, tube oil colours, thinned with turpentine or gold size, can be used for the polychrome effects discussed in this section. If more than one layer of paint is needed, thin the lower coats with turpentine both to help the paint to dry quickly, and to ensure that it will be lean enough to prevent the coats that are applied over it from cracking. Top coats that are required to dry with a shiny surface can be mixed with a little gold size, which will also help to toughen the film. Alternatively the work can be carried out entirely in oil colour and turpentine, and then varnished when it is dry. If oil glazes are mixed with a little gold size it will help them to dry reliably even when, as is often the case with transparent pigments, the colour is not a particularly good drier.

As an alternative to tube oil colour, artists' acrylic or vinyl paints can be used. These dry much more quickly than pigments in oil, and proprietary mediums are available to thin them and to make them dry with either a mat or glossy surface. These paints have not been available long enough for one to know how well they will adhere to metal in the long term, but their adhesion to conventional painting surfaces is good.

The following pigments are opaque in oil: titanium white, raw umber, burnt umber, vermilion, cadmium red, venetian red, chrome yellow, cadmium yellow, green oxide of chromium, cobalt blue, lamp black, mars black.

Transparent and semi-transparent pigments: raw sienna, burnt sienna, cobalt yellow, alizarin crimson, terre verte, viridian, indigo, prussian blue, ivory black and some of the dyestuff pigments, notably the copper phthalocyanines.

The following pigments from the above lists are particularly poor driers in oil: cadmium red, cadmium yellow, alizarin crimson, vermilion, terre verte, lamp black.

Pigments which are good driers are: raw sienna, raw umber, burnt umber, cobalt blue and yellow, and mars black.

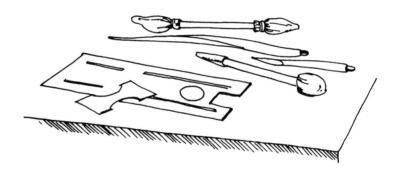

Bobs and stencils for applying bronze powders

Part 8. Varnish

Varnish on Gold

If one varnishes over gold leaf, the brilliant metallic quality which a well gilded surface has is destroyed, but in spite of this, some people regularly varnish with the idea of preserving the gold. In fact a well hardened oil gilded surface is surprisingly durable if it is not handled or rubbed excessively. Even on exterior work, where one might think that varnish would protect oil gilded decoration, it is likely that ultra-violet light and weather conditions will cause the varnish to deteriorate faster than the gold would if it was left exposed. However, where gold is combined with polychrome painting or bronze powders the whole surface is usually varnished. There are also some special finishes that are used on gold leaf and which are discussed at the end of the section on water gilding.

Varnishes for use on applied art objects need to dry within twenty-four hours to form a hard but not brittle film. When fully hard, the varnish should not be sensitive to friction, hand pressure or wax polish, nor be affected by warmth from the sun or other sources of moderate heat. On dark or warm coloured grounds, and on gold coloured metals, the tendency of a varnish to become yellower on aging is unimportant. However, it is better to use a varnish which does not become yellow on pale, cool-coloured grounds such as light blue or green, and also on white metals when the silver colour is to be retained. At present there is a tendency to prefer mat and satin finishes to glossy ones. However, if one looks at the inside of an antique japanned casket or cabinet that has remained closed for most of its life, it is clear that in the past varnishes were usually very glossy when new, and have only become mat where the surface has crazed as a result of being exposed to the light.

Any decorated surface must be allowed to become thoroughly hard before being varnished. If the varnish is applied too soon, the diluent in the varnish can affect the gold size, and bronze powders can be smeared onto other parts of the work. When metals that will tarnish have been used, more than one coat of varnish should be applied to give them adequate protection.

When gilding is combined with polychrome decoration or is on a painted ground, the length of time which the work must be left before it is varnished will vary considerably. Work may be varnished after a couple of weeks if it has been carried out in either commercial decorators' or artists' alkyd or vinyl paints. Work painted with traditional tube oil colours however, should be left for a minimum of six weeks and ideally for six months or longer. The oil paint must be given as much time as possible to oxidize throughout its thickness because once the varnish is applied the rate of drying will be reduced. This is particularly relevant if slow drying pigments have been used or the paint has been thickly applied in some places. It was probably, at least in part, the desire for a quick turn-round that caused the old decorators to paint so often with pigments ground in soft resin varnish instead of oil. The coating dried quickly and could be varnished without delay.

You need to be as fussy about dust when varnishing as you are when water gilding. Brushes must be scrupulously clean and should not contain loose hairs. Sable hair makes the finest brushes for varnishing but it is becoming prohibitively expensive. Ox hair, or a mixture of sable and ox are less costly and almost as good. Keep a small – ½" (12 mm) – brush for small mouldings and use a larger brush to apply the varnish quickly to flat areas and wide mouldings.

The room in which you varnish needs to be warm, dry and draught free. If you can arrange the object so that the surfaces to be varnished are nearly vertical, it will reduce the amount of dust which can settle on them as they dry. Do not wear hairy or woolly clothing which can shed bits on the wet surface. Try to plan your varnishing session so that it is the last thing you do in the room that day.

Paint stores and artists' suppliers provide a wide range of proprietary varnishes. Choose one which is suitable for the type of surface you wish to protect, and follow the manufacturer's advice on the way it is applied and thinned. If all the information you need is not printed on the container, a technical leaflet may be available on request.

Melamine- and polyurethane-based varnishes dry to form hard, clear coatings. They become irremovable on aging, and for this reason should not be used over elaborate decorative painting which may need to be cleaned one day. Acrylic varnish can be used over metals and flat paint coats and is particularly suitable for application over acrylic and vinyl paints. It is colourless, does not become yellow on aging and may be thinned with white spirit if necessary.

Copal varnish is not a suitable coating for decorative work because it darkens and quickly becomes irremovable. However, added to oil paint in small quantities, it will help the paint to flow to a smooth

surface and reduce its buttery quality as well as promote its drying and the formation of a hard film. If you wish to use copal, buy the palest ready-made varnish you can find, as it is not practical to make up copal varnish yourself from the dry resin.

Making up Varnishes

Although it is more trouble to make up your own varnish than to buy it ready made, if you prepare it yourself you can make the varnish heavier or lighter as you wish. The varnishes discussed below can be made by dissolving dry resin in a solvent without heat. The most you may need to do is to warm the varnish in a water bath before applying it. The best kind of water bath to use is an electric glue kettle with an enclosed element. Never stand a pot of varnish on an open flame, even if it is in a pan of water, as the solvent vapours are very inflammable and they may ignite.

Ormolu and other Shellac Varnishes

Shellac will dissolve in methylated spirit or iso-propyl alcohol and can be bought in flakes. Some people use bleached and dewaxed shellac for making a white varnish, but it has the disadvantage of forming a brittle film. In addition the flakes, if stored for some time, become difficult to dissolve. Shellac flakes that are described as 'decolourized' have become available recently and are said not to have these disadvantages. Lemon and other coloured shellacs do not form excessively brittle coatings and the flakes remain soluble almost indefinitely.

Ormolu is made by dissolving shellac in the proportion of ½–¾ oz (20 gm) to 10 fl oz (300 ml) of alcohol. The flakes will dissolve in the course of a day. The varnish should be filtered through muslin or a nylon stocking to remove any bits and then put into a tightly stoppered glass jar. Ready made French polish may be diluted to make ormolu but, because it contains additives, it may not produce as clear a result as varnish made from pure shellac.

A useful brushing and rubbing varnish which is thicker than ormolu can be made by dissolving 4–6 oz (150 gm) of shellac flakes in 20 fl oz (600 ml) of alcohol. This varnish should be filtered in the same way as ormolu. If it is then left to stand it will separate into a translucent brown top part which can be decanted, and a cloudy lower part which can be mixed with pigments to form a quick-drying paint. When diluted with an equal volume of alcohol the top part can be tinted with colours to make glazes or brushed onto gesso to reduce its absorbency before oil size is applied. The diluted clear varnish forms a quick-drying, relatively impermeable film which will protect bronzes and schlag leaf. The chief disadvantage of shellac as a clear varnish is that aged coatings are difficult to remove, but when used to make pigmented coatings its insolubility is an advantage.

Mastic and Dammar Varnishes

Natural resin varnishes made from mastic and dammar may be bought ready for use from artists' suppliers but, if you anticipate using either of them frequently, you may find it more economical to make your own. Coatings made with these resins tend to become yellow and brittle as they age, but they have the advantage that it is relatively easy to remove them, and they are therefore safe to use over chinoiserie and polychrome decoration. Both varnishes are liable to develop a milky surface on drying. This defect, which is known as 'bloom', is likely to occur if the varnish is brushed on in cold, damp conditions. If you warm the varnish in a water bath you will reduce the tendency for it to bloom and you will be able to brush it out more thinly.

To make a stock solution of dammar varnish, put 10 fl oz (300 ml) of artists' quality turpentine into a jar of about 1 pint (600 ml) capacity. Use a glass jar with a wide mouth and a well-fitting metal lid as turpentine will soften some plastics. Sprinkle 6 oz (180gm) of crushed resin into the turpentine, and stir the mixture well. Leave it to stand in a warm room stirring the resin several times a day until it has dissolved. Keep the jar covered to exclude dust and prevent the turpentine evaporating. White spirit or petroleum distillate cannot be used in place of turpentine because dammar resin does not dissolve fully in them. Dilute the varnish for use in the proportion of one part of stock solution to two or two-and-a-half parts of turpentine. The flexibility and toughness of dammar varnish can be improved if 5% of linseed stand oil, thinned with an equal volume of turpentine or toluene, is added to the diluted varnish. If dammar is applied to a surface on which there is the least trace of wax the varnish will remain sticky indefinitely but, surprisingly, a dammar coating may be wax polished once it has hardened fully.

Some nineteenth-century books on gilding recommend mastic varnish for protecting gold leaf that is subject to much handling. This probably meant architectural details such as skirting and door panel mouldings. Mastic may be made up in the same way as dammar, but the ratio of resin to solvent is slightly different. Dissolve 8½–9 oz (250 gm) of resin in 10 fl oz (300 ml) of turpentine and dilute one part of the stock solution with one-and-a-half or two parts of turpentine. Mastic varnish is easier to brush out evenly than dammar and is less sensitive to wax, but it becomes yellower on aging and is far more expensive.

You can also make these varnishes by adding the dry dammar or mastic resin to the full quantity of turpentine, and if you want only a small quantity of varnish this is probably the most satisfactory way. However, if you make up a concentrated stock solution, you have more scope for adjusting the viscosity of the varnish.

Ketone Resin N Varnish

Ketone resin N varnish provides protection for such things as polychrome painting combined with metal powders or gold leaf. It may be obtained from some artists' suppliers ready made, or you can buy the dry resin and make it yourself. Varnish made with this resin is virtually colourless and does not become yellow or insoluble with age; it dries touch hard in two to four hours and is fully hard in a day. Although the pure varnish is glossy and scratches easily, the addition of a small amount of wax has the effect of plasticizing and toughening the surface as well as making the varnish more mat.

To make a stock solution, place a weighed quantity of resin in a jar and add an equal weight of artists' quality white spirit. Turpentine is not recommended as the solvent as it makes a rather yellow varnish. Keep the mixture in a warm room and stir it frequently. It will dissolve completely in a few days to form a pale greenish-yellow solution.

For use, dilute one part of stock solution with one to one-and-a-half parts of white spirit. To make a semi-mat varnish take 12 fl oz (250 ml) of dilute varnish and add ¼ oz (5 gm) of bleached beeswax or microcrystalline wax. The amount of wax may be doubled if a fully mat varnish is required, but the coating will have less resistance to handling and accidental scratching than the version with the lower wax content. Dissolve the wax by warming the varnish in a water bath. When it is cold the varnish will be cloudy and slightly viscous; it must be reheated in the water bath until it becomes clear each time it is used and applied while it is warm.

Two or three thin coats of varnish may be applied without any perceptible increase in shininess and, when fully hard, the surface may be wax polished. If the varnish is reheated several times, some of the white spirit will be lost by evaporation and this may make the varnish more difficult to brush out evenly. If this occurs, a little white spirit should be added to restore the varnish to its former brushing consistency.

Changing White Metal Leaf to a Gold or Other Colour

Under names like 'changing varnish', recipes for a varnish to make white metal leaf look like gold, have been given in manuals on the arts for centuries. For example, Robert Dossie in the *Handmaid to the Arts* describes how to make a gold varnish for silvered leather hangings. These varnishes were used anywhere where large areas of gold leaf would have been unwarrantably expensive. Unfortunately not only do these recipes often require that the varnish should be boiled, but many of the dyestuffs – Dossie recommended aloes – are now difficult to obtain. Some alternatives are therefore offered which, because of the range of organic pigments now available, open up possibilities for non-traditional effects.

Aniline dyes are obtainable in bright shades and also in wood colours such as mahogany and walnut. Many are not very light fast, but whether this matters depends on the work you are doing. Spirit-soluble anilines can be used to tint the shellac varnish discussed earlier, but they are not compatible with turpentine. Dragon's blood and gamboge are two natural colouring materials which can be used with shellac. Dragon's blood is an orange red resin, which is only soluble in alcohol. It is reasonably light fast, stains quite strongly, and can be modified to give brownish red shades by the addition of a little transparent black such as ivory black in the form of dry pigment. Genuine lump gamboge will dissolve in alcohol, although it is more widely thought of as a water-soluble gum–resin. Gamboge is marketed in broken cylindrical lumps which, until they are wetted with water or alcohol, are a yellowish brown. It is one of the only yellow pigments which is transparent enough to be used over white metal leaf, but unfortunately not all pieces are equally light fast. It makes an excellent gold colour which you can modify to the exact shade you want by adding a little dragon's blood. Simply dissolve a little of each resin in alcohol and then add a small quantity of shellac varnish to the mixture. Although the colour can be painted on with a brush, the most even coating will be obtained if the varnish is applied with a rubber as in French polishing. Build up the colour to the required depth with several thin coats instead of putting on one thick one. Shellac may also be tinted with dry transparent pigment. The most useful colours are viridian, prussian blue and alizarin crimson which together with gamboge, dragon's blood and ivory black, can be used to create a wide range of colours.

The traditional oil colours which are transparent enough to be laid over white metal leaf without destroying its silvery quality are: the red lakes, verdigris, indigo, and Dutch and Italian pink – the last two are brownish yellow lakes. Of these, verdigris and Dutch pink are no longer available, but some artists' colourmen offer especially transparent oil paints. If you are interested, check the catalogue to see whether the colours are light fast. Because many of these modern transparent oil paints are coloured with organic pigments they, like lakes, do not dry well when painted over leaf unless a little clear gold size is added to them. When a glaze is applied over metal leaf the slightest unevenness will show and the addition of a small amount of gold size has the advantage that any brush marks will tend to flow out and disappear before the glaze is dry.

Part 9. Gold Bands on Harpsichords

The gold bands on harpsichord cases are often marked out with signwriters' tape. This has the advantage that it requires relatively little skill, but bands painted in this way can appear hard and mechanical. To paint the bands without the aid of tape requires care if the edges are not to wander, but the meniscus which forms where the gold size meets the paint will make an edge which is soft without being uncertain, and ensure that the bands appear to be an integral part of the decoration. If the edges are to be lined out with a brush you will need to mark their position first. You can draw on the surface of the paint with pencil or crayon. Alternatively, before the case is painted, you can incise the lines with a blunt point in the bare wood; the slight indentation will show through the paint but it will not be noticeable after the bands are gilded.

The width and placing of the bands is a matter of taste. Today, the tendency is to make the bands on the outside of the case 1–1¼" (25–32 mm) wide or even a little wider, while those on the inside of the lid are usually made narrower – ⅞" (22 mm) or less. You can experiment with the placing of the bands by sticking strips of low tack drafting tape lightly to the cheek, and moving the tape until you achieve a relationship between the width of the bands, the distance of the bands from the edges, and the size of the central area, which you feel is satisfactory. In general, the weight of the bands will need to be adjusted to suit the depth of the case, and the panels will appear more interesting if the bands and the border surrounding them are not made the same width. It may be necessary to place wide bands so that the painted border outside them is a little less than their width if the area they enclose is not to look cramped. Within reason the narrower the band is, the greater the flexibility in placing it. On at least one eighteenth-century harpsichord the bands are a mere ⅝" (16 mm) wide and are set almost 1½" (38 mm) in from the edges of the cheek, bentside and tail. On another instrument, the bands are 1⁷⁄₁₆" (36 mm) wide on the outside of the case and are set in by 1¹⁄₁₆" (28 mm); on the inside the bands are ⅝" (15.5 mm), and 1³⁄₁₆" (31 mm) from the edge of the lid.

When the borders round each panel are the same width, the strips of paint between the bands at the angles where the cheek and bentside, and bentside and tail meet, tend to look too wide. If the distance between each gold band and the angle is made a little less than the distance from the band to the top of the case – even by as little as ⅛″ (3 mm) – it helps the feeling of continuity along the bentside. If the case is intended to drop into the rebate of a framed up stand, the amount which will be covered at the lower edge needs to be allowed for. This is particularly relevant if the top edge of the stand is to be gilded, because it is the space between the gilded moulding and the lower band which will control the distance of the top band from the upper edge of the case. If the instrument is to have a trestle stand, the borders above and below the bands can be made equal, but the effect will be lighter if you make the bottom border ⅛″ (3 mm) wider than the top one. The bands on the lockboard should relate to those on the rest of the instrument and the easiest way to mark them out is to put the lockboard into its housing and mark the position of the bands at the ends and bottom by measuring from the outside of the case.

On the lid, because of its size, the bands can be set as much as two or three times their width from the edge. If there are battens across the lid where the flap is hinged, you will need to decide how far away from the battens you should place the band. A batten is always more noticeable if it has a gilded moulding on it, and you may find that it is the distance between this moulding and the band that determines the distance of the band from the edges of the lid.

Suppliers

All the following supply by post, and most will send goods overseas.
Materials relevant to readers of this booklet are noted in italics.

L. Cornelissen & Son
105 Great Russell St, London, WC1B 3RY
Gilders' supplies, resins, waxes and artists' pigments.

A. P. Fitzpatrick, Fine Art Materials
1 Barnabas Studios, 10–22 Barnabas Road, London, E9 5SB
Art and gilding materials, waxes, resins and Kremer pigments.

The Gilders' Warehouse
Unit 5, Woodside Commercial Estate, Thornwood, Epping, Essex,
CM16 6LJ
Gilders' sundries.

Dr Georg Kremer
Farbmühle, D-88317 Aichstetten/Allgäu, Germany
*Artists' supplies including an exceptionally wide range of dry pigments,
white and coloured clays, lithopone, natural and synthetic resins.*

Kremer Pigments Inc.
228 Elizabeth Street, New York City, Manahattan
Agent for Kremer Pigments in USA.

Richard A. Lingwood (Goldbeater)
Unit B, Braintree Road Industrial Estate, South Ruislip, Middlesex,
HA4 0YD
Gold leaf.

W. Habberley Meadows Ltd (Goldbeaters)
5 Saxon Way, Chelmsley Wood, Birmingham, B37 5AY
Fine quality English gold leaf, gold powder, and gilders' sundries.

E. Ploton (Sundries) Ltd
273 Archway Road, London, N6 5AA
Artists' materials and gilders' sundries.

Sepp Leaf Products, Inc.
381 Park Avenue South, New York, NY 10016, USA
Gilders' supplies.

Stuart R. Stevenson
68 Clerkenwell Road, London, EC1M 5QA
Artists' and gilding materials.

Alec Tiranti Ltd (www. tiranti.co.uk)
27 Warren Street, London, W1T 5NB
70 High Street,Theale, Reading, RG7 5AR
Sculptors' tools, materials and equipment.

Further Reading

BOURNE, J. *Lacquer*. The Crowood Press, Marlborough, Wilts.

EVETTS, L.C., *Roman Lettering*. Pitman, London. Taplinger, New York.

GERMANN, S., Regional Schools of Harpsichord Decoration. *Journal of the American Musical Instrument Society*. Vol. IV, 1978.

GOUDY, F. W., *The Alphabet and Elements of Lettering*. Dover, New York.

HUTH, H., *Lacquer of the West*. University of Chicago Press, Chicago & London.

JARRY, M. *Chinoiserie*. Sotheby's, London.

LeBLANC, R. J., *Gold Leaf Techniques*. Revised by A. O. Sarti. The Signs of the Times Publishing Co., Cincinnati, Ohio. Available in England from John T. Keep & Sons Ltd, 15 Theobalds Rd, London, WC1X 8SN. *Entirely devoted to signwriters' techniques, particularly gilding on glass.*

MAYER, R., *The Artist's Handbook of Materials and Techniques*. Faber & Faber, London.

O'NEIL, I., *The Art of the Painted Finish for Furniture & Decoration*. Morrow & Co, New York.

STALKER, J., and PARKER, G., *A Treatise of Japanning Varnishing and Guilding*. (1688). Reprint, Tiranti, London, 1960.

WARING, J., *Early American Stencils on Walls and Furniture*. First printed in 1937, reprinted by Dover, New York, 1968.

Index

Acrylic varnish, 62
Alcohol, 44
Alizarin crimson, 60, 66
Aluminium leaf, 4
Aniline colours, to tint shellac, 66
Bloom, on varnish, 64
Bob, 56
Bole, 41–43
Brime powder, 2
Bristling, 43
Bronze dust, danger of, 56
Bronze powder, 5, 55–6
Bronze, patinated, to imitate, 59
Brushes, 9
 crow, lark, swan, etc, 9
 for use with gold size, 17, 18
 for varnishing, 62
 how to choose, 9
 mop, 9–10
 squirrel-hair, 43
 to clean, 9
 to fit handles to, 9
 writers, 9
Burnishers, 10, 43
Burnishing, 46–7
Burnt sienna, 60
Burnt umber, 60
Cadmium red, 60
Carat of gold, 2, 3
Card used instead of tip, 33
Carving tools, for recutting, 39
Chalked paper to make, 49
Chrome yellow, 12, 60
Clays, 41–2
Cleaning up work, 31–2
Cloth
 for use in *intelaggio*, 36–7
 method of damping, 39–40
Cobalt blue, 60
Cobalt yellow, 60
Colours, *see* pigments
Copal varnish, 11, 62
Cotton wool ball
 used to press leaf down, 30, 34
Cushion, 7
 preparing leather of, 7, 23
 used by goldbeaters, 1, 2
Cutch, 1

Cutting gold leaf, 27
Design, transferred, 14, 49–50
Distressed gilding, 59
Double gilding, 45–6
Double tip, 6, 29
Dragon's blood, 66
Dust, avoidance of, 18, 43, 62
Dutch metal, *see* schlag leaf
Dutch pink, 66
Egg tempera, 57
Faulting
 on carving, 33–4
 on oil gilding, 30–31
 on water gilding, 46
French chalk, 10
Gamboge, 66
Gesso, 35–40
 amount needed, 37, 38
 constituents, 35
 to apply, 38
 to make, 37–8
 to test before burnishing, 46–7
 used under paint, 48
Gilders' whiting
 in gesso, 35
 natural chalk, 10
 stops spread of some sizes, 14
 when transferring designs, 14, 49
 used as resist, 14
Gilding
 see also gold leaf
 see also oil gilding
 see also water gilding
 bright and mat, 47
 cleaning up work, 31–2
 distressing of, 59
 double, 45–6
 moulding and carvings, 32–4
 water for, 44
Glue, *see* rabbit skin
Glue size
 preparation of, 35–6
Gold bands, *see also* lines
 defined by tape, 14
 on harpsichord cases, 67–8
Gold leaf
 adheres to greasy surface, 14
 book of, 1, 2

Gold leaf *cont.*
 carat of, 2
 colours of, 2–3
 cutting, 27
 double weight, 3
 fine, 2
 flattening on cushion, 22–6
 laying whole leaves, 29
 laying with a tip, 27–8
 loose, 3
 handling, 22–7
 moving to cushion
 by blowing over knife, 26–7
 by inverting book, 23
 by tipping from book, 23, 26
 overlaps in, 20, 27, 28
 pressing down, 29–30, 34
 regular, 3
 single weight, 3
 size of, 2
 standard, 3
 surplus, *see* skewings
 transferred
 advantages of, 3
 description of, 3
 faulting with, 31
 gilding strips, 21
 how made by gilders, 3
 insufficiently pressed, 21–2
 only used with oil mordant, 3
 removing from book, 20
 technique of gilding with, 20
 used out of doors, 3
 using whole leaves, 21
 vulnerable when not in book, 20
 white, 2, 3, 4
Gold powder, 5, 53
Gold size, 11–13
 'old oil size', 12
 added to paint to help drying, 66
 applying, 17–18
 brushes to use with, 17–18
 clear, 11, 54
 constituents, 11
 drying times of, 13
 mixing types of, 13
 quick japan, 11
 self-levelling property of, 12
 to remove, 32
 to test when ready, 19
 types of, 11–12

Gold size *cont.*
 variations in drying time
 reasons for, 13
 writers', 12
 yellow, 12
Goldbeaters' skin, 2
Goldbeating, 1–2
Green oxide of chromium, 60
Grounds
 colours of, 58
 imitation stone, etc, 58
Gypsum, 2, 35 *see also* Brime
Hammers, goldbeating, 2
Harpsichord cases
 gold bands on, 67–8
Indigo, 60, 66
Intelaggio, 36–7
Italian pink, 66
Ivory black, 60, 66
Knife
 gilders, 8
 how to hold when using tip, 28–9
 rubbed with rouge or chalk, 23
 to sharpen, 8
Knife, cane, 1
Lamp black, 60
Laying the gold, 27–9
Lays, 32
Leaf
 see metal, gold, tin etc.
Lettering, 50–53
 outlines & shadows on, 52–3
 spacing of, 50–52
 supports for use when, 18–19
Lines
 techniques of painting, 18
Mahlstick, 8–9
 use when lettering, 18
Mars black, 60
Melamine varnish, 62
Metal leaf, colours used over, 65–6
Metal powders, 5, 55
 resists for, 15
 see also gold, bronze etc.
Mop, *see* brushes
Muller and slab, 42, 53
Natural chalk
 see gilders' whiting, gesso
Oil gilding, 17–34
 cannot be burnished, 11
 finished with damp leather, 31–2

Oil gilding *cont.*
 known as mordant gilding, 11
 matted with parchment size, 47–8
 poor
 due to irregularities in size, 18
 when size is too soft, 19
 preparing surface for, 14–15
 technique of, 11
 used indoors and out of doors, 11
 with paint, 58
Oil size, *see* gold size
Ormolu, 47–8, 63
Outlines
 to enrich lettering, 52
 to enrich motifs, 58
Paint
 applied after gilding, 48
 drying to improve, 66
 pigments used in, 60
 types, with gilding, 48, 59
Palladium leaf, 4
Parchment clipings, to make size, 35
Parchment size
 used to mat oil gilding, 47
Pigments, 60, 66
Platinum leaf, 4
Polyurethane varnish, 62
Positions, working, 17
Pounce bag
 how to make, 10
 how to use, 14
Pressing down the gold, 29–30, 34
Pricking, 50
Prussian blue, 60, 66
Pumice slips, 39
Rabbit skin glue, 36
Raw sienna, 60
Raw umber, 60
Recutting, 38–40
Red lake, 66
Resists, 14–15
Roller, for pressing down, 30
Rottenstone, 59
Rubber, use of, 66
Rubbing varnish, 63
Schlag leaf, 4, 56–7
Scrapers, used for recutting, 39
Shell gold, 53–4
Shellac varnish
 called ormolu, 47
 coloured, 66

Shellac varnish *cont.*
 to make, 63
 use when patinating bronze, 59
Silver leaf, 4
 used to imitate gold, 4, 65
 with imitation tortoiseshell, 58–9
Size coat, 36
Skewings, 32
 use on carved work, 34
 to make gold powder from, 53
Stencils, with metal powders, 55–6
Strewings or Spangles, 54
Stump, 49
Supports for use when lettering, 19
Surface preparation
 for gesso, 35
 for leafing and bronzing, 14
 for water gilding, 43
Talc, 10, 18
Tape, 14
Terre verte, 60
Tin leaf, 4, 58
Tip, 6
 card used instead of, 33
 holding when water gilding, 44
 how to hold when using knife, 28
 narrow pieces cut from, 31
 not charged with static, 28
 preparing, 27
 squirrel's tail used as, 6
 technique of using, 27–9
 to store, 7
 two used for whole leaves, 6
Titanium white, 60
Tools, 6–10
Tortoiseshell, to imitate, 5–9
Transferring designs, 14, 49–50
Tweezers, 2, 6
Varnish, 61–6
 see also shellac
 acrylic, 62
 bloom on, 64
 brushes for, 62
 changing, 65
 copal, 62
 dammar, 64
 interval before applying, 61
 Ketone resin N, 65
 mastic, 64
 melamine, 62
 on gold, 61

Varnish *cont.*
 ormolu, 63
 polyurethane, 62
 properties of, 61
 to make, 63–5
Venice turpentine, 11
Venetian red, 60
Verdigris, 66
Vermilion, 60
Viridian, 60
Waggon
 described as a 'frame', 1
 used to cut leaves, 2
Water Gilding, 41–8

Water gilding *cont.*
 burnishing, 46–7
 damaged easily, 11
 faulting, 46
 how to apply the leaf, 44
 on carving, 45
 outline of technique, 41
 the 'water', 44
 with paint, 57
 early use of, 57
Wet polishing, 39–40
White of egg, *see* resist
Writers, *see* brushes
Yellow ochre, 12